Contents

Introduction iv

Living in fashion 1

Living it up 31

Living with you 47

Living with your body 65

Living with friends 79

Living with boys 103

Living with school 123

Living with family 139

Living green 155

Introduction

Are you a girl with bucket-loads of style and confidence, gutsy enough to say what you think and deal with the trickier elements of life? Can you make a dazzling entrance, exude calmness, and ditch a guy, all while looking fabulous? No? Well, you're not alone! When it comes to surviving modern life most of us are more than a little stumped at how to get by with some sass and style. So if you happen to be someone who's plagued by mini disasters like bad hair days, untimely spots and weird eyebrows, or fated to fall on her face at the wrong moment, and who feels perplexed by everything from fashion to festivals, this is the book for you.

Crammed full of practical advice, suggestions and helpful know-it-all tips, this is your guide to everything you've ever wanted to know, but were too afraid to ask. So whether you're a budding Cinderella desperate to find a ball-gown that fits, or an ugly sister in need of a major life transformation, *Bras, Boys and Bad Hair Days* is your ultimate fairy godmother. Read it, try it, and use it – you won't be sorry!

F/NIAI

The Learning Centre
South Kent College
Jemmett Road
Ashford, Kent TN23 2RJ

*Remember you can renew
books over the phone.*

Tel: 01233 655573

For Bella

*With thanks to Karen McCombie, Jenni Baxter
and experts everywhere for sharing their tips and advice.*

Copyright © 2008 Anita Naik
Illustrations copyright © 2008 Claire Clements

With thanks to Meiklejohn Illustration Ltd
(www.meiklejohn.co.uk)
Designed by Fiona Webb

First published in Great Britain in 2008 by Hodder Children's Books

The right of Anita Naik and Claire Clements to be identified as the Author
and Illustrator of the Work has been asserted by them in accordance with
the Copyright, Designs and Patents Act 1988.

1

A Catalogue record for this book is available
from the British Library

ISBN: 978 0 340 97057 7

Printed and bound in Great Britain by
Clays Ltd St Ives plc, Bungay, Suffolk

The paper and board used in this paperback by Hodder Children's Books are
natural recyclable products made from wood grown in sustainable forests.
The manufacturing processes conform to the environmental
regulations of the country of origin.

Hodder Children's Books
a division of Hachette Children's Books
338 Euston Road, London NW1 3BH
An Hachette Livre UK company

Living
in fashion

How to have style

Let's face it, some girls drip with style whether they're all dressed up for a party or on their way out to buy a pint of milk, while others try but never quite get it right no matter how much money or time they put into it. This is because having style is not about wearing the latest clothes or even about following fashion, it's simply about expressing yourself and being who you are without any apologies.

The good news is that locating your natural style isn't hard because it's all around you whether you realize it or not. To find it, write an 'I love' list of all the things you adore, from fashion to music to books to hairstyles to weird things that make you — well, you! Your list could contain items such as high heels, T-shirts, dresses, jeans, ballet shoes, silver earrings, long hair, hats, scarves, sci-fi films, comics, famous icons that your friends have never heard of, books that you love to read, and music that does it for you. It may seem like an odd mishmash of

ideas, but this is a list of your personal style, and once you have your list, it's time to start showing it to the world. Here's how:

❦ *Start with your clothes*

Do your clothes represent you, or are they something a magazine or a friend has told you to wear? Are you wearing any of the clothes from your 'I love' list or steering clear because you're afraid they're not in fashion? If your look is really someone else's, you need to create a new look for yourself that features a little bit of what you like and a little bit of what you feel you have to wear, and bingo – you'll suddenly have your own fashion style.

❦ *Think about your attitude*

Are you afraid to talk about the stuff that you like because you're scared it isn't cool and your friends will make fun of you? If so, bear in mind that having style isn't about letting others dictate your likes, but about showing them who you are. Which is why standing up for what you love and like is about as stylish as a girl can get because it screams originality.

Express yourself

Expressing your individuality is what having style is all about. Look around you and consider how others are expressing their style. You may not necessarily like what they're expressing or even consider what they're doing to be 'style', but you've got to give them credit for going for it!

Be daring and unique

But don't wear, say or do something if it's not you. Daring and unique means going against the norm for a change and, while it's tough to stand out, remember it's what stylish trendsetters do!

Do: Experiment – you'll never have style if you don't try on lots of different looks and ideas.

Don't: Expect everyone to love your style – this is about you, not them.

Do: Be accepting of people who have a different style to you.

Don't: Get locked into one style – it's your style, you can change it any time you want.

How to be fashionable

Here's a truth the fashionistas don't want you to know: being fashionable is something anyone, even the most stylishly challenged, can learn.

* Fashion fact one: you don't have to be a size 0 or have tonnes of money to achieve fashion glory.

* Fashion fact two: to be fashionable you don't need cash, all you need is an observant eye and the courage to flex your creative muscles.

Of course, being fashionable is not easy if you're currently clueless about fashion, so the best way to start is by people watching. Pay particular attention to the trendsetters who are considered movers and shakers in the fashion world both on a global level (i.e. celebrities) and on a local level (i.e. that girl in your class who always looks amazing). What are they doing that makes them look so good and what do you admire about their look?

Think about what you want. Are you aiming to be at the top of the fashion scale, or simply aiming to fit in with the majority?

If it's the former, buy a glossy fashion magazine, as this is your fashion bible to what's hot and upcoming in the next season. Quick tip – fashion is divided into four seasons and each season has what's known as 'key looks'. Note the look you like the most and then consider how you can tailor it to your cash flow and personality. This last part is vital because when it comes to fashion there's a fine line between looking current and looking ridiculous, meaning before you buy/wear anything ask yourself:

❀ Do I like this? ❀ Does it suit me?

❀ Is it really me? ❀ Would I wear it?

If an outfit involves something you've always felt was stupid such as a pirate hat, a shaved head or massive flares (all looks of the past), or a colour you hate, think twice. Nothing will ruin your fashion status more quickly than a bad fashion moment that your friends won't let you forget.

On the other hand, if you want to look as good as your friends, all you have to do is persuade your best-dressed friend to become your stylist for the day. Start by going through your wardrobe together and de-cluttering your worst items (i.e. give away/throw away/hide them!). Next, try on everything that's left, listening to advice about what works and what doesn't. Ask yourself: what key elements are

you missing and what lets you down on the fashion front?

Finally, go shopping. No matter how much money you have or haven't got (and choose your shops accordingly as nearly all have the same styles but at different prices) your job is to buy only three key items that will up your fashion status whatever else you are wearing. A well-known celebrity stylist suggests: a great bag, a fabulous pair of shoes and either a pair of good jeans or a jacket.

Again ask yourself the four questions above before you hand over your money and always, always, always try clothes on before buying. If you've done your homework, observed enough people and listened to the right advice, you can get dressed assured that at last you're on your way to fashion heaven.

Do: Grin and bear it if you make a bad fashion choice – it happens to us all.

Don't: Try to copy a friend's look down to the last detail – it's not fashionable to be a copycat.

Do: Experiment with different looks.

Don't: Take it too seriously – it's fashion, it's supposed to be fun.

How to buy a bra that fits

Buying the right-sized bra is your ticket to looking
more shapely all over, which is why it's worth
feeling embarrassed for two minutes during a fitting.
Avoid it and guess your size and all that will happen
is you'll fall into the 80 per cent of women who are
looking lumpy when they could be looking
fantastic. You are wearing a badly fitting bra if:

- The straps dig into the shoulder area, leaving
 nasty ridges.

- Your straps fall down your arms all the time.

- The front of your bra doesn't lie flat against
 your ribcage.

- Your boobs spill out from under your cups or
 out of the sides.

- The back is so loose you can get two hands
 underneath it when it's done up.

- Your boobs have no support when you run for
 the bus.

❀ Your boobs end up on your lap when you're sitting down.

❀ The underneath of your bra digs into your ribcage when sitting.

❀ You can feel your bra when you move.

❀ You've never been measured.

Finding your size is the start to finding the right bra for your shape, so begin by getting measured by an expert because doing it yourself is a tricky equation that most people get wrong. A fitting can be done in the lingerie section of any major department store and takes less than five minutes. Once you have your size, you'll have a number that is the measurement under your bust for example, 32, 34, 36, etc. (or Australian sizes, 10, 12, 14, etc.) and a cup size that is represented by a letter A, B, C, D and so on. Cup sizes start with AAA the smallest, and increase alphabetically. Double or triple lettering systems only occur before A (e.g. AAA for a size smaller than AA and A) and after D (e.g. DD, EE and so on). It's all to do with how bra sizes are worked out, so double lettering only occurs in small or larger sizes.

The next step is to try on lots of different styles. This is essential because, like a size 10 pair of jeans, no two bras are alike even if they both say 32B, plus

there are half cups (for women who are fuller at the sides of their breasts), full cups (for when you're full at the front) and balcony cups (when it's all a bit more equal), underwired (good if you need more support) and soft cup which has no wire (good if you're small).

All in all, a bra that fits well should be so comfortable that you don't feel it. The straps should not fall down or dig in and the band under your breasts should be tight enough that if you slide the straps off your shoulder, the bra will still support you.

Do: Have more than two bras as bras lose their elasticity when they are washed.

Don't: Think you never have to be measured again. Always get measured when you gain or lose weight or change shape in any way.

Do: Expect your bra to feel tight around the time of your period – it's water retention, not weight gain.

Don't: Go for fashion over comfort – your bra is your support structure not your outfit!

How to pluck your eyebrows

Eyebrows can make or break your face, which means going 'au naturel' is fabulous if you've been blessed with seductively arched brows that give you large baby-like eyes. However most of us have hairy caterpillars crawling above our upper face that don't do much for our looks, never mind our eyes. If your brows meet in the middle (and don't be embarrassed, many people's do), sneak off in ten directions, or stand to attention like soldiers on parade you need to do something – and fast.

1. Get your equipment right. Eyebrows are not shaped with scissors, disposable razors or eye pencils, but with tweezers.
2. Prepare your brows; the best and least painful way to do this is to pluck after a shower when your skin is warm.
3. Brush your brows upwards. If you don't have a brow brush/comb use a toothbrush (your own one preferably!) – this will help you to see any stray hairs that need plucking.
4. Get started on shaping your brows by plucking from underneath the brow so you don't ruin the natural shape of your arch.

5. Your eyebrow shape should always follow your natural shape and start in line with the inner corner of your eye and end just beyond the outer corner. Skinny thin lines may look good on a supermodel but may not on you. Likewise, thick bushy ones are best left to the celebrities who can afford to rectify mistakes.

6. Pluck all hairs from the bridge of your nose (remembering the rule above about where your brows should start from). Beware: it's very easy to get carried away once you start plucking, so make sure you go slowly and constantly compare brows to make sure that you are creating an equal look.

7. When you're done, brush your brows in the direction the hair grows, and look for bald patches where you've overdone the plucking. These areas can be disguised with an eye shadow powder or an eyebrow pencil in the right shade, slightly lighter than your natural brow colour, and always apply lightly with a brush.

8. Apply Vaseline to seal the look and stand back and admire your work.

Do: Tidy up mistakes with a brow pencil (use your natural colour) and a brow comb.

Don't: Over-pluck and assume it will grow back – eyebrows can take up to four months to grow back.

Do: Consider letting a professional do the job for you. Waxing and threading are the norms and both produce a precise and clean brow.

Don't: Let a friend do it for you.

Do: Ask a friend for advice on how you're doing.

How to walk in heels

If you're wobbly when walking in heels there are a few heel truths you need to get to grips with. Firstly, as much as you want to totter around in sky-high heels, walking with your bottom stuck out tends to indicate that you need a lower heel. Secondly, while high heels can instantly make your

legs look longer and sleeker, this won't happen if the heel is as chunky as a tree trunk or if your heel is so skinny it makes your calves look like tree trunks.
So in order to look good in heels you first have to choose the right-sized heel for you, and then teach yourself how to walk in them.

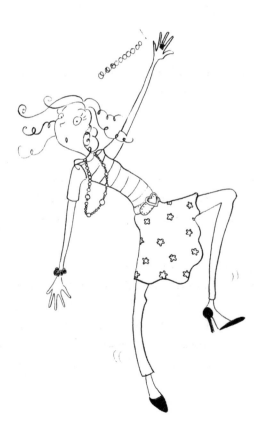

The general rule when purchasing heels is the thicker the heel the easier it is to walk (as there is a bigger surface area for your body weight to be distributed over) meaning wedges are a good choice if you find stilettos impossible to balance on. Always try the shoes on in a skirt so that you can scrutinize how they make your legs look and, unless you're aiming for a vintage 1950s look, never wear socks with heels!

Once you have your ideal pair, don't wait for an important event. Make sure you break them in before that special occasion because:

🌸 New high heels can be painful to break in.

🌸 High heels throw your body off balance and push your pelvis forward and this in turn makes you unsteady, so you need to get your walk right.

🌸 Walking in heels can also make you feel as if there are a thousand needles digging into your feet, because your entire body weight is tipped on to the ball of your foot. Again you need to give yourself time to get used to this feeling or else you'll spend your night out sitting down.

Step-by-step guide to perfecting your walk

Step one: Start slowly. Begin by standing up in your heels, feet hip width apart, which sounds easier than it is. Use your stomach strength to lift yourself up as opposed to bearing your weight down on your arms, which is not so dignified. The best way to do this is to imagine a string pulling you up from the centre of your head and, as you imagine this, push down on to the balls of your feet and rise up.

Step two: When you're standing and have found your centre of balance, lift one foot and take a small slow step forwards and don't take another one until you've placed this foot down and regained your balance. Try not to grip your shoes with your toes as you walk (as this can cause shin pain), and keep going, head held high, bottom in, using your tummy muscles to keep you upright.

Step three: The aim now is to perfect your walk and learn to do more than walk in a straight line. Start by sitting down and standing up a few times, then bending to pick something up. Finally, whenever you're home, walk around your room in heels to get used to them.

When you're able to walk easily with your head held high, try to build up a natural rhythm so that momentum helps you on your way – think model on a catwalk swinging her hips slightly, and go, girl, go!

One last tip to consider is walking up and down stairs. When walking up, don't lean forwards and stick your bottom out. Stand tall and walk up slowly, making sure that you don't take another step until your supporting foot is balanced securely. As for coming down, do yourself a favour and slip off your heels and go barefoot. Even Kate Moss does it!

Do: Take your heels off if they're killing you. It's impossible to walk gracefully when your feet are bleeding.

Don't: Borrow a friend's pair – high heels work best when they are worn by one owner only and fit properly.

Do: Consider high-heeled boots; they will give you more stability.

Don't: Try to dance in heels until you can walk.

How to grow your nails

Going from short and stubby to talons isn't hard as long as you're not an ardent nail-biter (though if you are, look at the Dos and Don'ts for tips). If you want perfect nails the first thing to get your head around is that, like your hair and skin, your nails are affected by what you eat and do. So if you have a nutritionally dead diet of fast food, and spend your time scratching and chewing your nails, the chances are your nails are going to be flaky, brittle, quick to snap off and slow to grow.

Nails are composed of a special kind of protein called keratin and you need good protein in your diet for them to grow strong. Meaning you need to eat fish, lean beef, eggs, chicken breast, turkey breast, or if you're vegetarian protein foods such as Quorn, with beans, nuts and seeds. Essential fatty acids like Omega-3, which is found in oily fish like salmon, will also help to make your nails grow, as will food rich in vitamins C, D, E and B. So if you eat five portions of fruit and vegetables a day you're on the winning stretch.

Alongside what you eat, you also have to think about what you're doing to your hands.

- Using your nails as a tool to pick, peel and tear at things

- plunging them into soapy water to do the washing up

- digging the garden with them or even scratching wallpaper off the wall

are all bad news. If you want them to grow, wear washing-up gloves, don't mindlessly use them as a tool and, after you wash, make a habit of applying a moisturizing cream to your hands and nails.

It's also worth noting that nail polish and nail polish remover are often made of harsh chemicals that don't protect or help your nails to grow. And false nails aren't a healthy alternative – the glue dries out the nails and the removal process can take off layers of the underlying nail.

The good news is that if you give your diet and hand habits a makeover, gorgeous nails can be yours, though you do have to be patient. Healthy nails take three weeks to grow about half a centimetre, so you can expect a reasonable length in six weeks' time.

Do: If you're an ardent biter who can't stop, try painting your nails with a 'stop biting' liquid.

Don't: Peel your nail varnish off – it will damage your nails.

Do: Moisturize your nails with almond oil.

Don't: Think white spots are a zinc deficiency. They are just due to mild trauma – such as hitting or slamming your fingernail on or into something, usually about four months before they appear.

How to apply make-up like an expert

Make-up can either make you look amazingly fantastic or amazingly like an extra from a horror movie, and the difference is surprisingly minimal – which is why it pays to know how to slap it on properly.

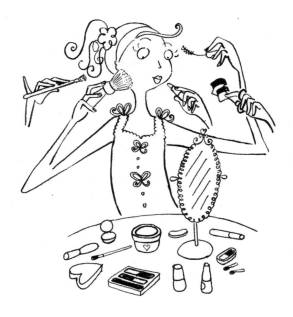

Make-up Rules

Before you start:

1. Always shop for new make-up with a naked face so you get the colour right.
2. Don't think expensive brands are the best — mix and match.
3. Foundation needs to be matched properly and not on your hand but your jawline. It should blend into your skin in natural light and not look lighter or darker.
4. Always buy a concealer — this should be slightly lighter in colour than your foundation.

5. Invest in some make-up brushes and sponges –
 you wouldn't paint the walls with your hands, so
 don't paint your face with your fingers.

Face

Pepare your face by cleansing and moisturizing.
Then apply foundation over your face with a
sponge or your fingertips in smooth movements.
Blend it outwards to your jawline until the
foundation sinks into your skin and doesn't leave a
line round your face. Pay special attention to
blending around the nose, mouth and jawline, as the
aim is to make the make-up merge in, rather than
look caked on. If it looks flaky or cakey around the
nose, it means your skin is dry here and needs more
moisturizing cream before the foundation. Next,
apply concealer lightly over your blemishes and
again blend in. Finally, blot face powder over your
face to help set your foundation and take the
shine off.

Eyes

Never overload eye make-up, as too much makes
your eyes look smaller. If you want your eyes to
look larger, go for a light colour of eye shadow
and use a brush to apply it. Then brush on some
mascara. To make your lashes look longer wiggle the

wand at the base of the lashes – mascara placed near the roots creates that luscious look. Eyeliner can be tricky (just look at some of the girls in your class for evidence of this), however, using a liner correctly can do wonders for your eyes. Eyeliners come in two forms: a pencil liner, which can give your eyes a soft sultry look, and a liquid liner, that can give you a dramatic look.

For best effects when applying:

1. Hold the upper eyelid taut with one hand, and with the other apply the eyeliner from the outside of the eye towards the corner of your eye – but don't go all the way in as it will make your eyes look smaller.
2. Don't line your eyes in one go. Apply in small strokes, or dots, until you have a nice line.
3. Always go for light coverage; a line that's too thick, or dark, will have you looking like a panda.
4. If you want to make your eyes appear bigger, gently trace the inner rims of your eyes with a white pencil. Again, do it lightly or else you'll have a startled look all day.
5. Clean up any mistakes with a cotton bud dipped in eye make-up remover.
6. Once done, allow the liner to dry before applying more mascara or powder.

Lips

Using a lip brush, apply a coat of colour on your upper and lower lips then blot your lips against a dry tissue, and repeat the process twice. This will help keep your lipstick colour on all day and avoid it sticking to your teeth.

For a glossy day look try some lip-gloss (or Vaseline on a budget). It will keep your lips moisturized and also give your smile extra impact. Don't smother on the gloss or you'll look like you've been attacked by a greasy chip. If you're in a hurry, put a small dollop in the centre of your lower lip and lightly press lips together. If you have more time, dip a lip brush into the gloss and colour your lips with a light layer.

Do: Have a slightly heavier look at night and a lighter one for days.

Don't: Be led by fashion. Eye shadows should be in the colour range that matches your eye colour and lipstick should emphasize your lip shape. For thinner lips use a dark colour, for fuller lips a lighter shade.

Do: Always take your make-up off at night.

Don't: Use make-up that's out of date – it's full of nasty germs.

How to deal with a bad hair day

We all have them – those days when our hair spends the whole day frizzing out, lying lankly or simply sticking out in all directions, and while there are worse things in life, having bad hair can make you feel downright dowdy and nasty. But before you reach for a large hat or a paper bag, here's how to turn your hair from bad to good.

Lank and limp

If you've woken up with your hair looking lank and limp and have no time to wash it, simply get out the hair dryer and blast it with cold air at the roots. This will lift it up and give it more volume. As tempting as it is to run your hands through it all day (in the hope you can help lift it up) – avoid this at all costs. All you're doing is making your hair even more lank and limp, which means a hair disaster for you all day. Instead, if by lunchtime it's limp again, grab a large brush, lower your head and brush your hair upside down, from the roots to the tips.

Straighten up, tidy your hair, and you should have more volume.

Greasy

If your fringe is plastered against your scalp and your hairline looks as greasy as a takeaway chip, and again washing is out of the question, invest in some dry shampoo. This miracle product comes in an aerosol can and will literally take away a greasy shine and leave you with a matt finish, plus it will make your hair smell pretty good too.

Static

If you're suffering from static fly-away hair, the best solution (and strangest) is to rub your hair with a tumble dryer sheet. In the same way it stops your clothes sticking together, it will tame your hair and help it to behave all day.

Dry and flat

Product overload is another cause of bad hair days. If your hair just won't do what you want and lies there as flat as a pancake you need to wash it with a clarifying shampoo, condition it and then avoid any product that promises shine, as this just coats the hair and makes it heavy and lank.

 Frizzy

If you're sporting a puff ball hairdo, it calls for
emergency action. Apply some hair serum or a tiny
amount of conditioner (the size of a ten-pence coin)
and, using your fingertips, lightly smooth over the
frizz. Then don't touch it and it should behave till
you have time to wash it.

If none of the above work and every day
is a bad hair day, you need to invest in a decent
haircut. A fantastic haircut stops bad hair days
because it ensures that as your hair grows it still stays

in style, so it's well worth the money. If you can't afford it, opt for a hairdresser that's looking for hair models. This is where supervised trainees cut your hair. It sounds scary, but you do get a say in what cut you get and the trainee is under supervision at all times, so you'll get a great cut that suits you.

Do: Use a leave-in conditioner and protective spray if you straighten your hair everyday.

Don't: Tie up greasy hair; it looks even worse.

Do: Love your hair and treat it well.

Don't: Keep drawing attention to your bad hair – chances are you notice it more than everyone else.

How to zap a zit

Zits, spots, acne, pimples – call them what you may, the one thing you can guarantee is you'll have an outbreak just when you're desperate to have clear skin. The good news is that there are a multitude of ways to get rid of nasty zits and picking at them is your last resort. Firstly though, the don'ts:

🌸 Don't pick at a spot with dirty hands. This is a guaranteed way to infect your spots, making them spread and look larger and redder than ever.

🌸 Don't blast a spot with toothpaste, cover up with make-up and/or make a spot into a beauty spot – all ways to irritate a spot and increase its size.

🌸 Don't go on a sunbed – the sun/sunbed is not good for your skin in any way and will not clear up your spots.

🌸 Don't squeeze! The big squeeze technique will always backfire and cause a small lump to turn into a nasty big one that hangs around for weeks.

The no-nonsense solution is simple: if you're going to pop a zit, do it right. Start by washing your face and hands, then take two clean cotton wool pads and gently press either side of your zit. Use your fingers, not your nails, to press and if the zit doesn't pop easily, stop. If it does pop, use another clean cotton pad and apply tea tree oil (a natural antiseptic) to it, holding it for a minute to stop it bleeding. Wait an hour before applying make-up to make sure it's dry.

If popping it is out of the question you have to wait it out, but you can help the process along by soaking a cotton wool pad in warm salt water and holding it over the spot for five minutes. Repeat several times a day to dry out the spot. If that fails, look for

products with benzoyl peroxide as this not only helps reduce bacteria on the skin but also acts as a peeling agent to help loosen blackheads and zap spots.

In a dire emergency if all else fails, here's how to hide it. First apply concealer in a fine layer over the top of the offending spot with your finger (do it too thickly and you'll make a large spot look even larger), then using a make-up brush apply a fine layer of powder to take off the shine. To get the right amount, dip the brush in powder, blow off the excess grains and dust over the spot to give a matt finish. Leave to dry and don't touch all night!

Do: Look after your skin – cleanse and moisturize, eat healthily, drink lots of water, etc.

Don't: Overclean your skin – it strips it of much-needed natural oils.

Do: See your GP if nothing you buy over the counter helps to reduce your spots. Ask for antibiotics – the main ones are tetracycline and doxycycline, as these will blast your spots away.

Don't: Expect an improvement to happen overnight. Results can take six months but looking after your skin works.

Living it up

How to get rich

Aside from playing the lottery and marrying a millionaire (neither of which you can do when you're under sixteen), and/or inheriting a fortune from a long-lost and unknown relative, waking up rich is unlikely. However there are ways to set yourself on the path to future richness.

The real secret to being wealthy is simply to educate yourself about money so you know from an early age how to make money, save money, spend money and, more importantly, invest your money so it starts making even more money for you!

Making money

Even if you're at school and you're too young to have a part-time job, it doesn't mean that making money is something out of reach. Firstly think about what you're good at: for instance, can you make cakes, or do you have green fingers, or are you surrounded by lots of personal clutter? All these things can make you some extra cash — for example, sell cakes to relatives and neighbours, mow someone's lawn, or sell some of your excess

clothes, shoes, bags on an online auction site like eBay. Better still, think of paid tasks you can do around the house; it may not be big bucks now but it will all add up.

Saving money

This is the part that can hugely increase your future wealth and the equation for saving is simple. In order to save money, you have to spend less than you make. So if you earn £5.00 a week or get that in pocket money, you have to spend less than that amount in order to save money. Luckily, to do this you don't have to live like a pauper, just minimize your expenses. For instance, do you really need to buy your lunch every day? Making a packed lunch could save you £2.50 a day, or £50.00 a month, or £500.00 in a school year.

Spending money

Another vital component in becoming rich is learning to spend wisely. That means spending within budget and always asking yourself, 'Do I need this?' when you're about to buy something. This is important because unless you're going to buy something that increases in value (which is unlikely because it's pretty much only property, gold and art that increase in value) everything you buy helps you to lose money. The best tip is to rate out of ten how

much you want a product before you hand over cash. If you aren't scoring an eight or more, don't buy it and save the money instead.

Investing money

A parent/guardian can help you with this bit, but basically all the money you don't spend and get given for birthdays and Christmas can add up to a tasty amount by the time you're eighteen. All banks and building societies offer savings accounts for under sixteens, some which are tax-free and have a high interest rate. Look for accounts that have high APRs – that's an annual percentage rate, i.e. how much your money will increase by in a year. For instance if you save £100.00 and the APR is 5%, you'll make an extra £5.00 on your £100.00 every year.

Do: Steer clear of store cards and credit cards – some of which you can get when you're sixteen. Being in debt is the biggest single factor that will stop you being rich one day.

Don't: Think the small stuff doesn't count – anything you spend or save adds up.

ℋow to be festival friendly

Festivals are hip and cool, but going to one unprepared is destined to have you calling home for a late-night pick-up. So while it might seem glamorous to turn up for the weekend in a T-shirt, pair of wellies and shorts, you'll be more than a little sorry when the temperature drops to a chilly zero and you can't find/buy/borrow a blanket for love nor money.

ℱestival survival guide

❀ Get down to the basics – and we mean the basics. While festival loos aren't as scary as they used to be, never venture forth without your own private loo roll. Alongside this, grab a mega pack of wet wipes as this is your ticket to instant cleanliness and saves queuing for showers.

❀ Speaking of being wet, festivals in mid-summer are ironically prone to monsoon-like rainfalls so pack a jumper, rain jacket and waterproofs. These may not be the grooviest of accessories but they make a huge difference between enjoying the bands and freezing to death in your tent.

❀ Pack a pair of leggings – these are not only ideal for sleeping in and perfect if your jeans get ruined, but act as super leg-warmers when the temperature hits zero.

❀ Take something to sit on because you really, really don't want to stand all day. The best thing for damp ground is a blow-up air pillow, or take one of your mum's cushions, wrap it in a black bin bag and, hey presto, it's waterproof!

❀ Consider your stomach. While there are food stands galore, the queues are huge, buying snacks all day can be expensive, and the stands may not even be open first thing in the morning. To keep hunger at bay think of quick snacks to pack like crackers, cheese, fruit and muesli bars.

❀ To really enjoy a festival be practical – you may think you'll be able to spot your tent easily but in an ocean of tents you won't, so attach something simple to yours to make it stand out, like a bunch of balloons, fairy wings or a flag.

❀ Make sure you and your friends have a clear meeting point in case one of you gets lost – and don't rely on your mobiles to keep you connected, as reception can be somewhat iffy in the countryside.

❀ Think about taking some games for when the crowds get too much for you: portable travel

games, a football/frisbee or even a radio, because there's no TV to slob out in front of!

Don't forget a torch. While the main fields are well lit, the tent fields aren't, and if you're heading back late at night, or need the Portaloo at midnight you're going to need something to ensure you don't end up sleeping in a field full of cows!

> *Do:* Always head off in pairs so if you get lost you're not totally alone.
>
> *Don't:* Leave valuables in your tent. It may all look friendly and laid back, but there's always someone who'll take advantage.

How to be gutsy

Being gutsy is about saying goodbye to who everyone thinks you should be and being who you want to be. You may not be able to imagine that you'll ever be the kind of girl to say 'Get lost!' to a bully or ask a fabulously gorgeous boy out, but even the shyest girl can be gutsier. All it takes is some gutsy know-how.

Ten ways to be gutsy

1. Take a deep breath and face your fears. This means ask the questions you've always been too afraid to ask, and while you're at it, answer a question in class without worrying about being wrong, or simply admit to someone that you don't understand something.

2. Don't be a follower – be a leader. Start by disagreeing with your friends when they say/do something you're against. True mates will welcome the new improved you.

3. Don't take life so seriously. So you fell over in front of the boy you fancied, split your jeans or didn't get a joke – gutsy gals just pick themselves up and move on.

4. Be fashion gutsy as well as personality gutsy and wear something different for a day just because you feel like it.

5. Practise, practise, and practise – the more you try being gutsy, the gutsier you'll be.

6. Don't let friends or family label you as the 'smart one', 'the pretty one', or even 'the naughty one'. Gutsy girls make their own labels as they know themselves best.

7. Take risks. That's measured risks that build your confidence, not scary risks that put you in danger.

8. Stop worrying about what other people think of you.

9. Be assertive, not aggressive, as that's the key to being gutsy.
10. Live in the moment – not in what happened yesterday or what will happen tomorrow, it makes you live life to the fullest.

How to shop

If you have piles of clothes, shoes, bags and accessories that you never wear because they are too big/small/weird or outrageous you need some expert tips to help save you money and make you shop like an expert so here goes:

❀ ***Tip one:*** Never shop in a hurry, or when you have a bad case of PMS – both spell shopping disaster. Instead make sure you feel good about yourself and have enough time to stop, survey what's on sale, try on and buy with ease. If you're time starved, don't do it; you'll only end up hating it or returning it tomorrow.

❀ ***Tip two:*** Don't shop with friends who pressurize you into buying things, or aim to style you as they would style themselves. These are not your shopping friends, so either shop with a stylish

friend who's self-assured enough not to want to make you her fashion twin, or shop alone.

🌸 ***Tip three:*** Know what you're looking for before you leave home. It's no good going out and hoping for inspiration to strike. You'll either come back with a panic buy or with something you'll have to return.

🌸 ***Tip four:*** Always try clothes on, because even if it looks fabulous on the hanger and/or on your mates, until you have it on your body you won't

la la la!

be able to tell if it's a good buy or not. Likewise, take a risk and try on styles and colours you would never usually opt for. You may think they are not you, but again you might be surprised.

✿ ***Tip five:*** Move around in the clothes you're trying on. Standing still, the dress/jeans may feel amazing, but how do they feel when you sit, stand and bend over? Are the seams pulling, buttons straining, zip stretching?

✿ ***Tip six:*** Always use a changing room with good lights and a decent mirror so you can see yourself from all angles. Look for signs of something fitting badly – bagging at the bottom, gaping at the neckline, not hanging correctly over your hips.

✿ ***Tip seven:*** Ask a salesperson for help – Saturday girls aside, most full-time sales people learn to spot what looks good (and what doesn't) on customers.

✿ ***Tip eight:*** Stick to your budget. Naughty buys feel exhilarating at the time, but will leave you in a cold sweat at midnight when reality sets in. Have a budget and shop in cash to make sure you stick to it.

✿ ***Tip nine:*** Check the store return policy – while you have statutory rights by law, shops don't

have to give you your money back just because you don't like something once you get it home.

❀ **Tip ten:** It's not a bargain if you didn't originally want it, have nothing to go with it and the colour or fit isn't quite right.

Do: Check your backside – it's amazing how many clothes look fabulous from the front and awful from the back.

Don't: Shop in the sales unless you are after something you know has been reduced.

How to travel light

Learning to pack like a pro is about realizing that a girl doesn't have to pack everything she owns just in case she's caught out. Here's how to minimize the load:

❀ Get your packing in perspective. You're not emigrating or going to a remote jungle where you can't buy or wash anything and your

holiday won't be ruined if you don't have the right pair of shoes with you. Bearing this in mind, lay out everything you want to take on your bed. Take away any item of clothes/shoes you haven't worn in the last year (minus holiday items like bikini and sarong and flip flops). The fact is if you haven't worn them in twelve months, you won't wear them on holiday.

go in!!!

❀ Eliminate items from the list that are
unnecessary for your specific trip: shorts are
not needed on a skiing trip, nor swimwear on a
city break, a winter coat at a beach resort, and
night-out gear when you're visiting your
grandmother!

❀ Consider what you'd pack if you could only
travel with ten absolute essentials. This includes
shoes, but not underwear. It's tough, but think
about what you wear at home in a week and
pack these items, along with some night-out
clothes and sleep wear. This is your core luggage
and should include clothes than can double up
as day and night gear and a pair of trainers, flip
flops and night-out shoes.

❀ Consider your toiletries, as this is the number
one area where packing goes into overload.
Remind yourself that you will not die without
your hair serum and you will be able to buy
toiletries abroad. As tempting as it is to load up
with brand-new containers, either use half-
empty ones or pour into travel-sized bottles to
make space in your luggage and lighten the load.
If you're travelling with friends and family,
remember to plan your toiletry luggage together
to avoid doubling up on items like deodorant
(but only spray – as a communal roll-on is not
so hygienic!), shower gel, shampoo and soap.

❀ Weirdly, it's the stuff you skimp on that you need to pack more of. So always envisage what you're going to be doing on the trip and pack accordingly. If you're going to be on the beach all day you need a beach towel, sun lotion and a book, plus a sarong or loose shirt to cover up with in the midday sun. A city break calls for trainers, a smaller bag to carry round with you all day and more T-shirts than shoes.

❀ Make sure you have enough underwear — it's the one thing you'll kick yourself for forgetting and don't forget to throw a spare pair in your hand luggage in case your suitcase goes astray.

Do: Roll your clothes when packing instead of folding. This allows you to pack more items and causes fewer wrinkles.

Don't: Use a large bag; it just makes you pack more.

Living

with you

How to fake confidence

Being the girl who can swan into a room and be the life and soul of a party is a tough act that not many can do. Luckily there are certain things even the shyest of the shy can try to give the impression of natural confidence. The key is learning to 'fake it, to make it' because bizarrely the more you fake confidence, the more confident you'll feel and the more confident you'll appear. So here's how to blag it:

🌸 **Think of your posture** – how can you spot a confident person in a room? Clue: it won't be the girl slumped in a corner, looking out apologetically from under her fringe. Positive body language is huge when it comes to faking confidence because it's how we all read each other. Which means even if you're too afraid to speak, walking tall will show others you're a no-nonsense type of girl. (Imagine a string from the centre of your head pulling you upwards.) And while you're at it, use this tip when you're sitting down and talking to someone as well. Don't be afraid to take up space, so never clutch

your arms around your chest, sit huddled in a chair, or hunch into a ball when someone talks to you. The aim is to get people to notice you in the right way.

❀ *Learn to control your voice* – we all have that squeaky mouse voice when we're nervous, so in order to fake confidence, you have to learn to control it. This means breathing properly, which is super easy as long as you're sitting up (when you're all squashed up the breath can't fill the lungs, which causes the squeaky sound). Make sure you drop your tone when you speak, speak slowly but with authority, and avoid letting your sentence rise up at the end into a question (a sure sign of an unconfident person).

❀ *Talk to people, not at them* – to appear super confident always ask people about themselves and really listen to their answers, being sure to make good eye contact as you do. However, don't stare. Simply make eye contact for a few seconds, look away and look back again, being sure also to add something to the conversation.

❀ *Be funny* – self-deprecating humour shows that you don't take yourself too seriously, but be careful because if you do it too much you'll look needy and down on yourself. For instance, it's a bad idea to make a joke about your looks or

your body as it makes people uncomfortable, instead tell a funny story about the time you did something stupid and it will show that you're confident enough to admit you make mistakes.

Do: Practise reading aloud to yourself. It can help you control your voice and tone and make you sound more confident in company.

Don't: Hold yourself upright from your chest – that screams insecure. Let your ribcage relax and hold yourself from your stomach.

Do: Slow down when you speak.

Don't: Rush to fill silences.

How to whinge minimally

It's official – we Brits are a nation of whingers and complainers and we like to moan about everything from the weather, to food, to our nearest and dearest. Thankfully it is curable, so if you've been tagged as a class A whinger here's how to change your tune:

🦋 *Just stop*

Yes, you can go cold turkey. Every time you hear yourself complaining, whingeing and moaning, stop mid-sentence and remind yourself you're not going to do it. To help yourself, tell all your friends what you're doing and ask them to remind you of your pledge.

🦋 *Don't indulge in a whinge-fest*

Whingeing is addictive and if you have a group of friends who also love to whinge and complain you could find yourself no longer having conversations but just moaning all the time. If that sounds familiar, really listen to what happens every time you're all together. Are you just doing it for the sake of it? Is someone else driving it or are you? Do you come away feeling down? If so change the subject (literally), and if they won't let you, consider a break from your whingeing mates.

🦋 *Do you really have anything to whinge about?*

Are you continually whingeing about the same old things like school, your teachers and/or a particular friend, just for the sake of it? If these things bother you, do something about it, or else stop complaining.

❧ *Be grateful*

So you have no money, the boy you fancy doesn't know you exist and your friends are all thinner than you – but what do you have to be grateful for? Make a list and stick it on your bedroom mirror so the next time you're whingeing by text/email or phone, you can remind yourself that though everything feels dismal, it really isn't!

> ***Do:*** Indulge in a good whinge now and again – when you've really got something to complain about!
>
> ***Don't:*** Believe all your whinges to be true – most are a symptom of tiredness.

How to up your self-esteem

So you hate how you look: you feel too fat, too thin, too small, too big, too weird – too everything. If that sounds familiar you're also too low on self-esteem, which means you could do with an emergency boost. To up your levels try the following:

🌸 *Step one: Challenge your thinking*

Everywhere you look are images of beauty that can
make you feel bad about yourself – but only if you
let them. The last bit being the key point, because if
you look around you right now you'd be hard
pushed to see perfection like that on the street, or at
your school or amongst your friends. Beauty images

 53

aren't real because they have had much money, time, make-up and digital mastery put into them, so don't make them your beauty marker.

🌼 Step two: *Realize your feelings affect your behaviour*

Feel ugly, miserable and blue and that's how you'll behave, because how we feel about ourselves is how we display ourselves to others. Instead, for a whole day, refuse to feel bad and push your good points to everyone – you'll be surprised at how good it makes you feel.

🌼 Step three: *Don't compare yourself to others*

We all do it, but it's a lose/lose game because it only leaves you feeling smug or worthless. The best way to boost your self-esteem is not to find someone worse off than you but to mix with people who make you feel good about who you are and what you have to offer the world.

🌼 Step four: *List all your best qualities*

Sit down right now and list all your achievements – the things you have felt good about, the things others have praised you for and all your best qualities. If you're stuck ask your two best friends to help, telling them you need a self-esteem injection, and don't fall into the trap of thinking they're just saying things to be nice.

Step five: Challenge yourself to do something you're afraid of

This is the ultimate self-esteem booster because whether your personal challenge is small, e.g. to say something to a boy you fancy, or huge, e.g. learning to snowboard or act in a play, conquering something you're afraid of makes you feel positive, strong and able to do anything you set your mind to.

Step six: Say positive things about yourself and others

Spend the whole day saying only good things about everyone (even someone you dislike) – it's a well-known fact that people who say mean and nasty things about others are even more mean and horrible to themselves. Saying nice things about others teaches you to say nice things to yourself.

Step seven: Accept compliments

Say 'thank you' and don't diminish the compliment by saying 'I only did . . .' or 'It's nothing'. Throwing away compliments is a sign of low self-esteem. Remember that the people giving you a compliment are being honest. If you throw it back at them, then all you're doing is teaching them not to give you any in the future.

> *Don't:* Think you can't change the way you feel about yourself – you can!

How to stop stressing

Do you look in the mirror and feel horribly stressed about your reflection, or imagine that you're going to fail all your exams and end up living in a box, or that you'll be single for ever – or until global warming causes a massive flood and ends life as we know it? Whatever your stress, here's how to get it under control.

Stress buster 1: Understand stress
Stress is self-perpetuating – the more you worry about being stressed, the more stressed you become, and so on and so on. When that happens, you keep your body in what's known as a constant state of alarm, which causes anxiety and a whole host of other symptoms such as insomnia, stomach pains and panic attacks. Knowing this can help you to realize you do have control over what your mind keeps playing over and over.

Stress buster 2: Stop worrying about the things that you have zero control over
World peace, green issues, global warming, poverty, or when your boobs are going to grow – these are all things we feel bad about but can't change overnight, so no amount of worrying will make them better.

🌸 Stress buster 3: Identify the cause of your stress and take action

Put your stress into perspective and do something about it. Worried about how you'll look at a party? Ask your mum and best friend for help and advice. Fearful about an exam? Talk to a teacher about it. Worried you'll make a fool of yourself when you have to give a speech? Have a practice run through with friends.

🌸 Stress buster 4: Realize that not all stress is bad

Challenges can be stressful, but that doesn't mean they should be avoided. Use your stress as a motivator and you'll not only tackle your challenge more effectively but ultimately banish your stress in this area for good.

🌸 Stress buster 5: Talk about it

Nothing diffuses stress faster than talking about it. Confessing to what's freaking you out not only makes a big problem seem smaller but also gets it out of your head, so you can start to relax and feel calm.

Do: Live in the moment – it stops you stressing about what may or may not happen.

Don't: Think you're powerless to fight stress – you are always able to change your response to a situation.

Do: Take one step at a time – jumping ahead before you're ready is a guaranteed way to feel stressed out.

Don't: Assume life can be stress free – some stress is good, it's too much stress that's bad.

How to exude calm

You're about to make an entrance/say something/ talk to a boy you like/try to impress a girl you want to be mates with, but your palms are sweaty, your voice is stuck in your throat and beads of sweat are trickling down your back. Here's how to sweep panic aside and exude calm:

🦋 *Smile*

Think of someone or something that makes you smile and feel happy, or imagine a big smile rising up from the pit of your stomach all the way up to your face. Be sure not to let others catch you out with a fake grin; always make sure your smile reaches your eyes.

🦋 *Talk slowly*

… but not so slow that someone thinks you're insane. Nervy, anxious people talk quickly so slow down your chat. If your voice is caught in your throat and making you sound squeaky then the trick is to breathe out before you speak, as this then restores your breathing to normal and your voice will come out as planned.

🦋 *Think of something outside of yourself*

… whether it's how nice the weather is, or how pretty a room is or how many people there are wearing red. The idea is to stop thinking internally, which makes us more nervous, and focus outwardly so your body has no time to be jittery.

🦋 *Visualize success*

It's corny but it works – we're not talking success in a global or famous way, but success in the present. For instance, if your nerves are about talking to someone you fancy, picture yourself doing it successfully, and them asking you out; if you feel odd about making a speech or walking into a party, picture yourself doing it to a shower of compliments and then just do it.

❧ *Don't watch yourself*

This sounds odd, but when you're about to do
something that's scary, don't turn the spotlight on
yourself and scrutinize yourself doing it. This is a
guaranteed way to lose your calm and crumble
under pressure. Focus on getting through it moment
by moment.

❧ *Breathe*

It sounds ridiculous, but the number one way to
exude calmness is to keep breathing. When
nervous, scared or afraid, most people tend to hold
their breath (think of what happens when you're
watching a terrifying DVD) and that in turn leads
to a shaky voice and sweaty palms.

❧ *Don't take things so seriously*

So your worst fear is you'll fall over, spill a drink on
yourself, say something stupid, do something stupid,
or all of the above and more. Tell yourself 'So what
if I do?'. No one's perfect, and if you can bounce
back from disaster and laugh off your mistakes,
people will love and adore you and the last thing
you'll worry about is your calmness quota.

> *Do:* Fake it to make it.
>
> *Don't:* Smoke or drink to steady your nerves, it has the opposite effect.
>
> *Do:* Hang out with calm people.
>
> *Don't:* Ask a stressed friend for support.

How to say no (and yes)

How can you turn down your best mate when she wants to borrow your treasured DVDs or jeans? Or the boy you fancy when he asks to borrow your homework? Or even a family member who asks you to help her out with a loan again? A girl's got to learn how to say no to life's relentless requests, so here's how:

Remind yourself it's not rude to say no

Don't fall victim to the disease to please – saying yes when you want to say no is a good way to drive yourself crazy. So if your gut's crying 'No' – follow through, and if the person asking is offended by your refusal, remember they shouldn't have presumed you'd say yes.

🦋 *Don't be rude in your refusal*

There's a huge difference between being assertive and being aggressive, and it's easy to mix up the two when you feel trapped in a corner. Assertive is to say no in a nice but not apologetic way and aggressive is to be hostile and angry with your refusal.

🦋 *Don't over-explain yourself*

If the person asking won't take no for an answer they are likely to try the 'explain yourself' ploy in order to change your mind, so don't fall for it. For instance if it's a friend asking to borrow money and you've already said no, and she keeps asking why, just say, 'Sorry, it's one of my new rules' and change the subject.

🦋 *Don't allow yourself to feel guilty*

Guilt is a waste of time, especially if you know your answer was right, so if you're feeling bad it's either because someone is making you feel that way, or you're being too hard on yourself. If it's the latter, keep reminding yourself that you don't have to please people to get them to like you, friends will still be friends even if you say no. If a friend is playing the guilt card, refuse to be drawn into her scenario. It's not your fault she's got no money/ hasn't done her homework etc.

Don't say no all the time

There are times in life when it pays to say yes, or
learn to say yes because when it comes to doing
things we find challenging most people's response is
at first to say no. Say no too often and you can lose
out on doing things that can be (a) a lot of fun and
(b) teach you a lot about yourself. If you're a no
kind of girl have a yes day – that's a day in which
you say yes to everything you're asked (within
reason!) and see where that leads you. (One tip:
don't tell your friends what you're doing as they'll
try to test you.)

Do: Say no to things you feel are
reckless and dangerous.

Don't: Say no to things that take you out
of your comfort zone.

Do: Practise saying no if you find it hard.
The key is to make your 'no' firm but
friendly.

Don't: Be a martyr just because you're
afraid to say no.

Living
with your
body

How to stop being weight conscious

Think you're too fat, too heavy, too thin, or too small? The good news is you're not alone, the bad news is that being fixated about your weight is a confidence zapper. So if you're someone who limits what she does and what she wears and how she behaves because of your weight, here's how to stop being so weight conscious:

✤ Realize you're making yourself feel horrible

Weighing yourself constantly and examining how fat you think you are only increases critical thinking about your body and adds to body discomfort. Instead, focus on the fact that what you weigh has nothing to do with what kind of person you are or the kind of person your friends see. Ask yourself, do you judge what kind of people your friends are by what they weigh? They don't either!

🦋 *Break the weighing habit*

Weighing yourself every day is only a ticket to being weight conscious, what's more it's pointless because all you're doing is seeing how your weight fluctuates due to water, hormones and your menstrual cycle (some girls can put on about 7lb around their period). So avoid weighing yourself every day at all costs and if you really want to chart if you need to lose or gain a few pounds do what the experts say and go by how your clothes feel.

🦋 *Don't play the compare game*

While it's normal to compare yourself to your friends, if you don't feel you measure up it can be damaging and make you feel worthless – the answer is not to do it. Easy enough to say but hard to implement, so start by limiting the amount of time you do it each day. If you catch yourself doing it all the time, limit it to five minutes once an hour and check yourself regularly to make sure you keep to it, your aim being to get it down to five minutes in two hours, and then five minutes in three and then once a day etc.

🦋 *Refuse to let others define you*

Does your mum monitor your eating, your father comment on your shape, and your siblings tease you

about your body? If so, it's time to take control and say STOP! Point out to overzealous parents that their comments hurt, and aren't helpful, and don't let siblings define who you are. Often people's so-called helpful concerns are about themselves not you, and they try to push them on to you.

Feel good about yourself

What do you do best? What do your friends love about you? What subjects are you good at? What secret talents do you possess? Sometimes, it's the stuff we take for granted about ourselves that we should really fixate on and not the areas we feel we're lacking in. So write an 'I'm Great At This' list and stick it on your bedroom mirror to remind yourself daily that no matter what you weigh or don't weigh you're fantastic just the way you are.

Do: Realize that 67 per cent of girls think they are overweight and only 19 per cent are!

Don't: Think losing weight is the key to happiness.

Do: Bin your weighing scales.

Don't: Jump on other people's scales: no two set of scales are the same.

How to dress for your figure

The answer to looking good in clothes is not plastic surgery or a permanent stylist or even serious dieting — it's simply identifying your body shape and dressing for that shape. There are five different body types: apple, upside-down triangle, hourglass, pear, diamond and straight. Identify your shape, follow the fashion rules for it and you'll look fabulous — even in your school uniform!

Apple

Literally an apple shape — it means you have a round figure, full bust and narrow hips, and slim legs.

Do wear: Clothes that make you look longer and leaner: skirts that show off your legs, styles that accentuate your narrow hips, V-necks that give you length at your neck, skirts that are fitted and stop at the top of your knee or below (never on your knee), bootleg trousers.

Don't wear: Horizontal stripes, long baggy jumpers, tight-fitting clothes that make you look rounder in the middle area, narrow trousers.

Upside-down Triangle

This means you are wider at the top and leaner at the bottom, so you tend to have broad shoulders, a medium bust, narrow hips, and long legs.

Do wear: Skirts and jeans on your hips, go wider to balance out the top half of your body, and experiment with wearing longer tops as you're one of the few shapes that can get away with it.

Don't wear: Narrow skirts or trousers.

Hourglass

Think Coca–Cola bottle shape, which was rumoured to be based on this curvy shape. It means you have a good bust, small waist, curvy hips and a shapely bottom.

Do wear: Draw attention to your waist by wearing belts, nipped-in semi-fitted tops, ballet-style wrap tops and V-necks.

Don't wear: High necks and baggy styles, as they'll just make you look round.

Pear

Like an actual pear, you have a slender top and full bottom, hips and full thighs.

Do wear: Fitted and clingy tops that make the most of your upper shape with round or square necks, dark fabric skirts and trousers that make you look leaner.

Don't wear: Narrow skirts and trousers.

Straight

The straight body type is the desired model look, but if you have it you might be wishing for more curves or more of a bust.

Do wear: The good news is you can wear most things.

Don't wear: Steer clear of wearing too fitted clothes as it will just make you look smaller and straighter.

Do: Experiment and try on different looks and sizes to get the perfect fit.

Don't: Stick to the rules if you really do want to wear a latest look. At the end of the day, your shape is just a guide to fashion and it's how you put things together that counts.

How to deal with your lumpy bits

There are many ways to deal with your lumpy bits. You can throw yourself into a fitness regime and radically change the whole of your body, disguise the parts you hate well with fashion (see above), or simply obsess about the parts that offend and start wishing you could be someone else. Thankfully by far the easiest solution is to deal with them.

❧ Work out which bits you can change and which bits you can't

There are parts of your body that are naturally lumpy because of your genetic make-up. To help yourself come to terms with these parts look at the women in your family. If they are all buxom and curvy, chances are your own body is not going to be the replica of a 6ft supermodel no matter how much you wish you'd grow 5 inches and lose 10lb.

❧ *Do something about the parts you can change*

Doing something doesn't mean starving yourself or beating yourself up about not having the willpower to diet, it means getting fit. Exercise is the key to obliterating stubborn lumpy bits because it trims away the fat and replaces it with muscle which takes up a third less space than fat. (Don't worry, you're not going to turn into a beefcake, because you don't have the same hormonal make-up as a man.) You'll lose inches all over, and so lose the lumpy bits.

❧ *Get moving*

You don't have to love physical education (PE) or love sport to do exercise, as exercising is simply about getting moving and staying active. Try walking instead of taking the bus, going for a swim instead of shopping, and getting up to switch the TV over instead of hunting for the remote. The more active you are, the fitter you'll be and the more you'll find you quite like exercising.

❧ *Think about what you're looking at*

Are you a magazine junkie? Studies show it takes just thirty minutes of looking at a magazine to make a woman feel bad about her looks. So if you feel lumpy, think about what you're viewing and how that may be making you feel bad. The solution

(if you don't want to give up magazines) is to simply view images with a more critical eye, being aware that what you're looking at has been digitally altered, made up and improved, i.e. you're comparing yourself to something that's not real.

Do: Work on the parts you can change.

Don't: Become obsessed with how your body looks – it's a total waste of time and energy.

How to have your cake and eat it

Can you have a healthy diet and still eat cake? Of course you can, and chocolate and crisps and fast food, but – and this is a big BUT – a healthy diet has a little bit of everything, which means if your diet has more of the above than fruit and vegetables the chances are you're having a bit too much cake. So here's how to get healthy and enjoy it.

 Don't deny yourself what you like, it will only make you want it more. Make sure once a day you have your treat – though make sure it's treat sized and only once a day.

 Be honest with yourself about what you are eating. Keep a food diary for a week to see if your intake is a healthy balance or an unhealthy mess.

- Always eat five portions of fruit and vegetables a day. That's five altogether, so a fruit smoothie, an apple, a salad at lunch and carrots and broccoli with dinner would hit the spot.

- Read food labels, so you know what you're eating. For instance a 'healthy' flapjack has more sugar, fat and salt than a chocolate bar. A large bagel has more calories than a jacket potato and a can of fizzy cola has more sugar than a biscuit.

- Be careful what you drink. Although 100 per cent fruit juices are healthy, they are full of sugar – as are flavoured water and fizzy drinks. Stick to water, it's good for you, it's cheap and it won't do anything nasty to your body.

- Don't skip breakfast. 50 per cent of people do, thinking they are being healthy, when in fact studies show that not eating breakfast actually backfires on healthy eating efforts. They are so hungry by the time lunch comes around that they lose all semblance of self-control and eat everything in sight.

- Think about junk food. Most people love fast food/junk food because it tastes good. That's because it is high in fat and salt and sugar. Junk food is OK once a week but not every day. So limit burgers, pizza slices, hotdogs, chips, and crisps, biscuits and cakes.

Don't limit dairy, especially if you're about to hit puberty. As a girl, you need calcium and some good fats for healthy periods and growth, so don't cut out milk, cheese, yoghurt or ice cream. If you want to be healthy opt for half-fat varieties – the same nutritional benefits with half the fat.

Eat stuff you have to chew. Cereals – bread, pasta, rice and other foods from grains – all provide carbohydrates, which are important sources of energy. Without them you're going to feel lethargic and tired all the time.

Think colour. If you look down at your plate of food and everything on it is a shade of yellow, orange and brown you're most likely eating something unhealthy and loaded with fat. A healthy plate of food should display an array of colours, so if in doubt follow the rule that every plate of food should have four or more colours on it. Get that right and you're eating well.

Do: Think portion control when you eat and never eat something bigger than your face.

Don't: Buy diet foods – eat normal food, it's healthier and more sensible.

Living
with friends

How to make friends

It's easy when you're five years old, isn't it? Your mum plonks you in a room of mini strangers and leaves you to get on with making friends, then suddenly before you know it someone's grubby little hand is in yours and you're best friends. However, when you get older it's easy to suddenly find yourself a Norma No Mates, through no fault of your own. Thankfully there are some no-fail ways to make new friends. Here's how:

🦋 Spread your friend net wide

So you're in your bedroom yet again, moaning about how you never meet any new people or like any of the new people you meet. Well, aside from going to school and out to the shops with your mum, where are you planning to meet new people? To make friends you have to cast your net far and wide.

Join groups that you enjoy (think about what you're into), try a social network online (though don't always believe what you're being told by someone, and never ever go off and meet them alone), go to places where people your age look friendly and

hang out there. Your aim is to mix with as many different people as possible because the more people you meet, the more likely you are to find some great friends.

Smile when you meet people

… as in look friendly, not manic when you spot a friend in the making. Why? Well, because research shows people are much more likely to respond positively to you if you look welcoming. So when you're out and about, if you like the look of someone, look up, make eye contact and smile. If they then smile back (and 99 per cent will) follow through by saying something. It doesn't matter if it's a corny 'Do you come here, often?' or a comment like 'They serve good coffee here, don't they?' – the trick is to start up a conversation in order to find out if you've met someone you could potentially gel with.

Ask people to be friends

Those who wait to be asked, end up going nowhere, meaning there's no shame in initiating a friendship. If you meet someone you seem to have a lot in common with, take it to the next step. Suggest you hang out somewhere, go somewhere or simply do something together. Don't make a big deal out of it, and if they can't make it, don't immediately assume they are rejecting you. Give them your email or

mobile number and leave the ball in their court. Likewise, if someone asks you somewhere and you can't make it, don't just say no, but suggest an alternative date.

✿ *Have fun*

No one wants to be friends with a moaning Minnie, so if you want people to flock to your side, show them you are fun by having a good time when you're out. Meaning if PE is your idea of hell on earth, it's no good joining all the school sports clubs just to make friends because that's where all the popular girls hang out. Choose instead to do something you like and you're guaranteed to meet like-minded people that you have plenty in common with.

Do: Take it slowly with new friends because what you first see isn't always what you get.

Don't: Overdo it with a new friend; twenty texts and calls a day is overkill on the friend front.

Do: Have lots of friends, rather than just one best friend.

Don't: Succumb to a clique.

How to deal with annoying friends

The trouble with friends is that, though we choose them, we don't always know if they are going to turn out to be worthy of our friendship. Over time, someone with friend potential can go from a ten out of ten to a paltry four out of ten thanks to bad behaviour. So if it's their whines that are getting you down, or the fact that they're one of those me-me-me kind of girls, eager to suck you dry every single day, here's what to do:

1. Be honest about what's happening
While all friends can be annoying there's a clear distinction between daily annoyances from your friends and being annoyed daily by them. When their name pops up on your mobile phone does your stomach turn with fear and dread? If so, they have crossed that line and are officially an annoying friend.

2. Say something
Some friendships can still be saved, but only if you think (a) the friendship is worth it and (b) the

annoying person in question can change. The way to find out is to broach the subject. Either highlight your case subtly and back yourself up with: 'It really gets me down when you do that because . . . ' or say very loudly, 'DON'T DO THAT – IT GETS ON MY NERVES'. The latter is clearer, though obviously a little more hurtful, but it will get your message across.

3. Set boundaries

The next thing to do is set boundaries, also known as giving this person a chance to change. We're all guilty of waiting too long to say our piece and then one day exploding. However, it pays not to do this because the person may not realize they are being annoying, so work on a 'three strikes and you're out' basis. First strike, they get a gentle warning; second strike, a firm reminder; third strike, and they're gone.

4. Cut them loose

If you're cutting them loose, be kind. You don't have to kick them when they're down, but at the same time don't be a wimp about it and overdo the apologies or say, 'It's not you, it's me.' Remember you are taking charge of your life, and you owe it to yourself to have friends that don't get you down, so what's there to apologize for?

5. Don't let the experience put you off

So you found a bad egg of a friend; it doesn't mean everyone is like that. Don't be afraid to dip your toe

in the friendship water again, just take your time, consider where it all went wrong last time and don't make the same mistake twice.

Do: Listen if someone says you're annoying – they might be right.

Don't: Think it's you – it's not your fault if a friend's behaviour irritates you (unless you know you're being irrational).

How to make up after a fight

She said some ugly things, you said some mean things, you both shouted loudly and now you're not speaking – the only problem is you miss your friendship and want her back. So here's how to make up.

1. Don't wait too long
It's always easier to make up sooner rather than later. Wait too long for her to cool off or for her to take the first step and she'll only write you off or you'll both relive the fight over and over, fume and get even angrier with each other.

2. Call her

But before you do, think about what you want from your conversation. Are you looking for her forgiveness or an apology? Do you want to rehash what happened or pretend it didn't happen? Whichever your inclination, bear in mind that neither pretending it didn't happen, nor going over the row again will mend your friendship; neither will expecting her to be the first to apologize. So if you're calling, be clear about what you're going to say and why before you dial her number.

3. Apologize properly

It's easy to say sorry, but not so easy to say sorry and mean it. So if you're going to apologize make sure you do it the right way. Firstly, never ever say, 'I'm sorry, but . . . ' as what you're really saying is you're not sorry at all. Secondly, say it as if you mean it, because nothing rankles more than a fake apology. And lastly, don't add conditions to your apology, i.e. 'I'll say sorry if you say it first', or 'I'll say sorry if you promise'. Apologizing is about taking responsibility for your part in the fight. So if you don't feel you were to blame but feel bad about one part of your spat, apologize for that instead.

4. Make amends where you can

Ask her what you can do to make things right between you, and consider her requests, within reason. The idea here is to make up, not start another fight or cause more resentment between you. Maybe she needs time, or some space or an agreement from you that it won't happen again.

5. Consider you may get rejected

Perhaps your fight was a step too far or something hit the spot and can't be repaired. Either way bear in mind that no matter how sorry you are now and how much you're trying to make things right, it takes two to make up after a fight. So if your calls, texts and emails aren't being answered, you may have to accept this is not a fight that you can make right.

6. Don't bear grudges

You've made up so it's time to move on, which means don't harbour secret resentment about having to be the one who mended your friendship. The aim was to fix things, and you've done that, so be proud of yourself.

Do: Listen as much as you talk.

Don't: Take the blame for everything, unless of course you were to blame for everything.

How to be a good friend

The weird thing about being a good friend is everyone thinks they're one, but the reality is most of us aren't. If for instance, you're guilty of gossiping, not listening, faking a compliment or bad-mouthing a friend behind her back, even for a joke, it's time to really test your friendship mettle with the facts below:

1. You can keep secrets

She may say you're sworn to secrecy but a good friend knows the difference between the secrets you

can't keep and may need to tell (i.e. the dangerous ones – like knowing that a friend is planning to meet someone from the Internet), and the ones that are meant for your ears only.

2. You don't gossip about her

Also known as you don't bad-mouth and trash your friends behind their backs, even if they are irritating you beyond all reason or doing something you think is off.

3. You're kind but honest

The truth hurts, but you know it doesn't have to if you do it the right way. If you're stuck over how to do it, turn the tables and imagine it's her that has to tell you that you have bad breath or you have horrible taste in boys – how would you like her to say it kindly?

4. You listen as much as you talk

And also make sure you talk as much as you listen. You know that good friendships are equal and shouldn't have one of you holding court the whole time and the other being the cheerleader.

5. You are there for her

You should be able to spot when something is up and be there for her whether she is lonely or miserable, without her having to ask for your help.

6. You are happy for her

It may sound ridiculous, but some friends just can't be happy for their friend's successes. When something good happens you are someone who can celebrate with them and are genuinely happy for them.

7. You can boost her esteem

You know just what to say to remind her what a fantastic person she is and you don't hold back in telling her.

8. You keep in contact
… and don't play hard to get by ignoring emails and texts.

9. You introduce her to your friends
… and make friends with hers — because you know if she likes a person, you will too.

10. You're completely yourself with her
… and that's why your friendship is so amazing.

Do: Make sure she knows she's a good friend to you.

Don't: Be clingy or weird with her.

Do: Have lots of other friends as well as her.

Don't: Insist she's friends with only you.

How to break out of a clique

If you are thinking of emigrating or changing your identity to escape a clique, there is an easier way, but just in case you're wavering on whether to leave or not, it's worth bearing in mind that cliques by their very nature work because they leave people out – which means there are very few nice cliques. So here's your seven-step plan to a clique-free life.

* **Step one:** Know the difference between a group of friends and a clique. A clique is a tight group that has a strict code of rules about how to act and behave, and often tries to make it appear that they are 'better' than everyone else. A group of friends, on the other hand, are open to new people joining in and encourages everyone to be him or herself.

* **Step two:** Start spreading your friendship wings and make sure you talk to people outside of the clique. It can be hard at first, but what have you got to lose? Look around and talk to someone who's being friendly to you or someone who makes you laugh, or someone you admire. Your aim is to diversify and widen your friendship circle with all kinds of friends.

🌸 ***Step three:*** Cliques tend to try and make all members the same and can pressurize you into giving up things that you love. So be true to yourself and make sure you do the stuff you like doing, even if it's not 'cool' and 'acceptable' to the clique. Join school groups that suit who you are, and online stuff that merges with your interests. Remember anyone can follow the pack, but it's going after what you want that will make you happy.

🌸 ***Step four:*** Start being a 'no' kind of girl when the clique asks you to do stuff with them. You don't have to say no to everything (which can be scary) but no to the stuff you don't agree with. Members of cliques want everyone to be the same and are less likely to want you with them all the time if you're disputing their rules and regulations, like wearing what you want, and don't feel you have to fit in to be liked. Have a mind of your own and don't go along with what you don't believe is right – something most cliques try to get you to do.

🌸 ***Step five:*** Ask for help, especially if you feel worried about breaking free. Maybe there's someone away from the clique that you can confide in or your mum or a relative you trust. Tell them what's going on and let them be a support to you.

🦋 **Step six:** Move slowly but surely to avoid confrontations. Some cliques can get nasty when you start moving away, so don't do all of the above at once, but slowly plot your escape, making sure you can gradually extricate yourself.

🦋 **Step seven:** Work on knowing who you are. This is the ideal way to break out of a clique, because once you know who you are and what you enjoy – whether it's to do with school, TV, boys or fashion – you'll be a hundred times less likely to let someone else tell you what to do with your life.

Do: Tell someone if leaving gets too scary.

Don't: Let others control your life. Remember it's *your* life, not theirs.

Do: Support others who want to break out too.

Don't: Bad-mouth them once you're gone. Why start a fight?

How to give advice

It's easy, right? Someone asks for your advice and you tell him or her what to do and that's it in a nutshell. Sadly, it's not, because you may be blamed for a potential disaster. Here's how to dish advice the right way.

Problem: Your friend may be doing the stupidest thing on earth and dating a boy who you and all your friends know is just going to break her heart!

Solution: Whatever you do, do not tell her that, unless she first asks for your advice. And this is the cardinal rule of advice giving: always wait until someone asks for your advice. Dish it without asking and you're just going to be blamed or told it's none of your business.

Next, be sure you don't fall into the advice trap. This is where a friend asks for your advice, ignores it and then keeps coming back to ask for more and more advice. The trick is not to be swayed by her story, or drawn into it. If she doesn't take your advice the first time round then the chances are she has no intention of ever taking it and is just looking for someone to bore to death with her drama.

If you still want to be known as the queen of advice, you need to be kind about your advice and learn to accept advice as well as give it. Remember you are giving suggestions and ideas for what someone can do to get out of a sticky situation, not orders. So if they don't take your advice, don't get angry, or indignant. As for taking advice, you're showing others that (1) you understand what it's like to get into a fix and need help and (2) you're human and have problems like them.

Also bear in mind, when asked for advice don't be afraid to say you don't know, when you don't know! You may want to be the oracle of knowledge, but there will be times when you're going to be stuck for advice or simply unsure what is the right thing to do. When this happens, ask someone else or go online and try and find the 'right' answer because bluffing your way through it is a recipe for disaster all round.

Lastly, before you give any kind of advice, don't think about what you'd do in the same situation, but put yourself in your friend's shoes. Remember you are giving advice and can't judge someone on what they are telling you; you can only try to help them. So if they are confessing to doing something wrong and asking for your advice, it's not your place to tell them off or insist they confess to all.

Do: Be kind when dispensing advice.

Don't: Act superior when trying to help
someone.

Do: Be aware that your advice may be
wrong.

Don't: Say, 'I told you so.'

How to forgive

Are you someone who thinks forgiveness is
overrated, or says she forgives but secretly harbours
dark and resentful thoughts? If you want to say,
'I forgive you' and really mean it here's how:

Be the better person

It's probably what your mother always told you,
sometimes a girl's got to be the better person and
forgive lesser souls who can't quite help themselves.
However, smugness aside, before you forgive
someone make sure that you are forgiving him or
her for the thing that hurt you. Meaning figure out
what you actually need to forgive them for. If they

stole your boyfriend, was it the fact that they stole your boyfriend, or the fact that they betrayed you or the fact that they lied to you, or everything and more? Be specific about what you're forgiving and what you're not.

🦋 *Put what's happened in perspective*

OK, so they have been nasty, and you've been left hurt and in pain, but in the grand scheme of things, have you got over it yet? If you have, it's no good pretending you're still hurt just to punish them and make them feel bad, because all it does is keep you in the moment. Instead put the event in perspective, and if you're well and truly over it forgive them and move on.

🦋 *Become a forgiving person*

It sounds weird, but in order to forgive someone, you have to be a forgiving person. If you harbour grudges, remember every horrible thing your siblings ever did to you, and can reel off a list of past hurts, you're probably not the forgiving type. However, you can be and you should be because if you can't forgive others, it's likely you can't forgive yourself and that's a horrible state of mind to be in.

✿ *Remember life's too short*

As in, life really is too short to waste time being angry at people who don't deserve your time, so forgive them and then you'll stop thinking about them. After all, forgiving doesn't mean accepting what they've done, excusing it or even forgetting what happened, it simply means that you've accepted they acted badly towards you and you've moved on.

Do: Write down why you're angry – it can be a cathartic way to get rid of anger.

Don't: Relive what happened over and over, all it does is bring back the emotion over and over.

How to break up with a friend

Breaking up with a friend is tougher than breaking up with a boy because what you're basically saying is, 'I don't like you any more'. Aside from being super scary, the guilt of hurting someone (even someone intensely annoying that you don't want to be friends with any more) can leave you in a cold sweat. The road of least guilt is as follows:

✿ Know why you're ditching her

Be clear in your head why your friendship is over. It can help to write a pros and cons list so you can verbalize why you feel the need to end things. This list is just for you and not for her, so be as honest as you like. When the list is done, use it to remind yourself of why you're ending the friendship every time you feel guilty.

✿ Consider telling her why it's all over

This is not an excuse to be nasty or hurt her feelings, but a way for you both to reach closure.

Sometimes it will: for example, pointing out that she's been mean, nasty and spiteful may help her to see the error of her ways; but if you've just grown apart, or know she's particularly vindictive when crossed, avoid 'honesty' at all costs.

✤ *Slowly slide out of a friendship*

This is by far the best way if you can bear to drag it out, as it's the road of least confrontation and less likely to end in a row. Basically what you do is slowly move away from her. For instance, if you spoke on the phone every night cut back to four times a week, and then twice a week, and then once a week and so on and so on. If you spend all your time together, start making excuses and setting up 'things you can't get out of' in your spare time. Your aim is to give her a hint and also wean her off you at the same time.

✤ *Be prepared for questions*

Meaning have an answer ready. A good reply would be to say you're just busy with school and home stuff and it's nothing personal, but you think you should spend less time together. Try not to over-explain yourself or say the irritating, 'It's not you, it's me' (because it's obviously her).

🦋 Don't involve all your friends

Avoid turning your break-up into an Oscar-winning drama with a cast of thousands. It's your decision and your break-up, and if you start involving all your mates and asking them to take sides, you're basically declaring war on your ex-friend.

🦋 Be nice

Finally, even if she was the friend from hell, when you bump into each other, which you will, it pays to be nice (even if she's being vile). Keep it short and keep it sweet, because to do anything else just prolongs a relationship that you're simply trying to get away from.

Do: Make a clean break.

Don't: Text her why you're ditching her.

Do: Be honest with other friends about why you're no longer friends with her.

Don't: Feel bad – not everyone's a friend for life.

Living with boys

How to get a guy to like you

1. Do smile when he looks at you – it screams 'I'm friendly'.
2. Do have your own life and friends – no one wants a puppy following them about all day.
3. Do show him that you know how to have a good time – who wants to date a moaner?
4. Do get his attention (but in a positive way).
5. Do make the first step to talk to him – why wait for him to do it?
6. Do have a sense of humour – boys like girls who know how to laugh.
7. Do get to know his friends – to work out if he's someone you would like.
8. Do show interest in what he likes (though see number two above).
9. Do be a good friend to him as well as a potential girlfriend.
10. Do invite him out in a group – so he has time to get to know you and your friends.
11. Do drop hints that you like him – so he realizes you want more than friendship.
12. Do ask him out – he'll appreciate it more than you think! (See next 'How to'.)

13. Don't pretend you're not interested – game playing is a guaranteed way to end up single.
14. Don't pretend to like the things he likes if you don't – unless you want to spend all your dates bored out of your mind.
15. Don't morph into his ex-girlfriend – she's an ex for a reason.
16. Don't be clingy and jealous – it screams 'possessive'.
17. Don't be best friends with his mum – it's annoying and weird.
18. Don't call him ten times a day – are you a stalker?
19. Don't snog his best friend – do you want to be single again?
20. Don't compare him to your ex (see fifteen, above).

How to ask a guy out

It's the noughties, which means not only can you ask a guy out but you can also sweet talk him, kiss him and then dump him all in the same day. Of course, that's probably not your plan, so if you're still trying to work up the courage to get him to be your boyfriend here's how to do it.

1. Have realistic expectations
If he's twenty-five and you're fifteen, or he's hooked up with someone else, he's not going to say yes, which means you're wasting your time and your energy.

2. Read his signals correctly
Before you launch into a 'Will you go out with me?' make sure you have (1) laid the groundwork and (2) have an idea if he likes you or not. To lay the groundwork you have to do some flirting, meaning smile at him, talk to him and make eye contact. If he's responding, smiling back and making an effort to chat, you're on to a possible winner. At the same time, ask around – is he single? Does he like you? Is he looking for a girlfriend? Knowing the answers to these makes your question more likely to have a positive outcome.

3. Remind yourself that boys like to be asked out
Why? Well, because it saves them the agony and pain of having to do it themselves, plus it's intensely flattering, and on the whole if you've read the signals correctly (see above) nine out of ten guys will say yes. If you bear this in mind you'll find the courage to step up and ask him out.

4. Plan how you're going to do it
Unless you're a 'fly by the seat of your pants' kind of girl, it pays to have a plan so you don't stumble

and fall over your words or blurt it out in front of twenty people you don't know. Plot how you're going to ask him, i.e. know where you're going to do it, how you're going to do it and what you're going to say. If you're very nervous, ask your best friend to role play with you and when she does (i.e. she pretends to be him) ask her for different responses so you also have a get-out plan in your head.

5. Don't build it up in your head
While role-play scenarios are good practice, running it over and over in your head just causes an adrenalin rush and puts your body on panic alert. Instead, make a plan, run it through and then distract yourself until the time comes to ask him.

6. Say what you mean
Be clear when you ask. Men aren't good at reading between the lines, so if you're vague and say something like, 'Maybe we should hang out sometime' or 'I like you', he's going to be unclear about what you want and so unclear about an answer, which means you'll have wasted all that energy for nothing.

7. Don't beat around the bush
Just say it. Start with a little small talk to gauge his mood (i.e. make sure he hasn't just had a fight with his mum or lost his dog) and then say, 'Fancy going to the movies/a party/to a friend's house on

Saturday?' Keep it short, keep it sweet and make sure you give him time to answer. If he says he can't because he's already going out, don't assume this is rejection – suggest an alternative plan or give him your mobile number and tell him to call when he's free. If, however, he says 'Sorry no/I'm not interested' etc., make a graceful and fast exit.

Do: Keep asking guys out – the more you do it, the less frightening it gets.

Don't: Make a rejection all about you – you don't know what's happening in his life right now.

Do: Feel good about the fact you asked him out.

How to give an expert kiss

Forget what to do with your hands, how to cope with excess saliva, and what to do if you can't breathe, the first vital component of giving an expert kiss is having good dental hygiene. Stinky breath and mossy teeth will register even the most

expert kiss as a big fat zero. While this isn't an invitation to be obsessive about your breath, it does always pay to have a packet of mints or chewing gum on you pre-kiss and to avoid smoking (literally the kiss of death!).

Next, make sure you practise some kissing etiquette. Don't just swoop down on the person you want to kiss and kiss him, make sure (a) he wants to kiss you back and (b) you have time for a proper kiss. This is because a rushed kiss can never be expertly given and if you're worried someone is going to walk in on you, your mind won't be on the job in hand. So choose your moment well, and think about your location. A standing-up kiss is great if you have a wall to lean against, a sitting down one is a bit trickier but equally enjoyable. But one given at the back of a bus or in equally awkward positions again limit the expert quality of your kiss.

Finally, before you begin, make sure the person you're kissing doesn't spoil the moment. Some boys insist on taking control, but you can stop this by refusing to let them hold your head or hair (instead ask for a cuddle hold), and by dealing with tongue plungers by swiftly pulling away before they reach your tonsils.

Once all of the above is in place, it's time to deal with the kissing basics.

❀ **Step one:** Tilt your head to one side as your lips meet so your noses don't clash then slowly start to tease his lips with small feather-like kisses.

❀ **Step two:** As you're doing this use your body – run your fingers through his hair and across the scalp, rub his arm and gently give him a hug.

❀ **Step three:** Move in for a longer kiss – open your lips slightly and gently move your head as you kiss him. Remember – and this is important – to come up for air because you can only kiss for so long before both of you need to breathe. Pretend you don't, and you'll either pass out or suddenly have to jerk away to take in gulps of oxygen.

❀ **Step four:** Let him lead a little, because thinking about how your partner likes to be kissed and to kiss makes for an expert kissing session all round. If he's reluctant to take charge, try various actions. Slow, fast, hard and soft, see how he responds and go with the flow.

❀ **Step five:** Don't worry about saliva. Sloppy kisses happen because couples forget to swallow as they are kissing, so a build up of saliva occurs in the mouth. It can help to keep your tongue relaxed but your lips fairly tight, but if you feel you can't swallow, pull back for a second, swallow and start again.

🌸 **Step six:** Don't be so quick with your tongue. Plunge in too soon and you could spoil it all. First-time expert kisses are all about exploring the territory. Meaning finding out if (a) you like kissing this person, (b) he likes kissing you and (c) you want to go further with your kisses. Until you know this information, steer clear of the French kiss.

Do: Practise – because practice makes perfect.

Don't: Panic if it goes wrong – it's just a kiss, not an exam.

Do: Bear in mind if it goes wrong it's not totally your fault.

How to get over a guy

So you're broken-hearted, engulfed in misery, you can't eat, you can't sleep and all you can think is: what are you supposed to do now that he's left you? Well, it's time to get over that guy before you turn into a soggy tissue. The heartbreak solution is as follows:

❀ *Remember all the bad stuff*

Forget how he used to sweetly text you before you went to bed, or his pet name for you or even how good he was at kissing. If you want to get over him remember the bad stuff. Recall how he had stinky breath, or snorted when he laughed, or had that annoying habit of ignoring your comments or being pushy. Remember how you secretly hated the way he danced/dressed/ate/spoke or the time he annoyed and irritated you. Then say good riddance to bad rubbish.

✿ **Six boyfriends and then Mr Right**

Or so say the statistics, which means a girl's got to risk more than one broken heart if she's serious about finding Mr Right. And rather like a dodgy fashion choice, use every broken relationship as a way to redefine your idea of Mr Right, i.e. look at your list above and make a promise that next time you won't put up with any of those features.

✿ **Don't stalk him**

Stop accessing his page on Facebook/MySpace/Bebo etc., stop texting him jokes, and don't follow him home, call him at midnight or question everyone who has a passing relationship with him about what he's doing and who he's with. Unless you plan a future as a private detective, all you're doing is turning into a stalker and feeding your heartbreak habit.

✿ **Have a celebrity crush**

It's too soon to fall in love again, but it's never too soon to transplant your feelings for him on to a famous person and indulge in a crush. A celebrity crush is an ideal way to get over heartbreak as it encompasses all the excitement, thrills and passion of falling in love but from a distance, so you don't actually run the risk of getting hurt.

❀ *Let go*

Accept that the relationship is truly over because you cannot begin moving on until you completely give up on your ex. Which means you have to discard the last shred of hope that you may get back together; stop trying to be 'friends' because you think it will make him realize his mistakes and come back to you.

❀ *Keep yourself busy*

As hard as it is, try to keep your mind occupied – which means don't sit around by yourself moping, and don't do things that give you time to ponder and feel sad. Instead of indulging in the misery, totally exhaust yourself by doing new things that physically tire you out by the end of the day.

❀ *Find yourself a new boyfriend*

Let's face it, the best way to get over heartbreak is to eventually fall in love again with someone better and brighter than before, so you can thank your ex for dumping you in the first place!

Do: See your friends even if it's to cry.

Don't: Torture yourself by reliving the past.

Do: Put it down to experience.

Don't: Let it put you off men for good.

How to flirt

Some girls are born flirts, while sadly the rest of us just have to practise until we make the grade. The good news is, no matter how socially inept you feel you are, you too can become an expert flirt because flirting is not about fluttering your eyelashes and pretending to be a pathetic girlie but about flexing your charm muscle and showing the world that you're ready, present and able.

1. Walk tall and make eye contact
All good flirts know the benefits of good posture because the truth is no one will ever notice you if you sit slumped in a corner or walk into a room staring at the floor. So your first lesson in good flirting is to hold your head up and make eye contact with someone you fancy. The best flirt trick is to look over, hold their glance for a second, look away and look back straightaway to see if they're still looking. If they are, they're interested.

2. The importance of smiling
Your smile is the next essential part of your flirting skills and will take your attraction to the next stage as long as it's genuine and you don't grin like a

maniac. The way to smile correctly is to look at the person you fancy and genuinely think of something that makes you smile and let that smile reach your eyes (the sign of a real smile is one that travels up your face). If you're smiling the right kind of smile and they are interested they'll smile back. If they don't smile or they turn away, it means they are not interested (for whatever reason) and you should move on.

3. Say something friendly

The next step is to take a deep breath, walk over and say something. Don't get caught up on what you say because you don't have to be the funniest girl in the room or the cleverest or even say something mind-blowing, but you do have to say something. Again read his signals – is he smiling, looking pleased or desperately looking around for a friend to bail him out as he says hello back? If you're stuck, consider his body language – has he turned away from you or is he facing you full on – and more importantly, what's your gut telling you about his response?

4. Be tactile

If it's all going well, now is the time to take your flirting to a new level with some tactile skills. Tactile means making physical contact, but does not mean trying to kiss him or be sexually overt. To be tactile simply touch his hand when speaking or playfully hit his arm, the aim is to stick to areas which are safe – which means avoiding more personal areas like his face, neck and legs – and see how he responds.

5. Reciprocal Disclosure

The final part of flirting is to try what's known as reciprocal disclosure. This is where you trade intimacies/anecdotes to see if you're on the same level. If you're both interested, trade some small talk

and see if it does the trick. If it does, suggest you go out sometime, give him your number and walk away. This is the essence of flirting – always leave them wanting more, i.e. don't overstay your welcome.

Do: Practise flirting in your daily life – practice makes perfect.

Don't: Label yourself a bad flirt if your initial attempts don't go well.

Do: Be open to other people's flirt signals.

Don't: Think flirting is bad. It's something we all do whether we realize it or not.

How to dump a guy

Breaking up is not easy to do. Aside from the difficulty and embarrassment of having to say, 'Sorry, bud, but it's over', being the breaker-upper will make you feel guilty even if he was the loser boyfriend from hell, so here's how to make it short and sweet.

🦋 *Choose your method well*

While dumping someone by text is bad etiquette, meeting in person to say 'It's over' is highly overrated. For starters, who needs to be face to face with someone who's going to say, 'I don't love you any more and what's more I don't want to see you any more' – it's mortifying and shocking, never mind humiliating. A better bet is to do it by phone, or email (if you're better at expressing yourself with the written word). The idea is to tell them you've had second thoughts and if they then want to meet to discuss it you're open to it. This then gives them the option to either erase you from their address book or meet you and battle it out face to face.

🦋 *Less is more*

As in when you're telling someone it's over, use fewer words and more action, i.e. say what you have to say and leave. Over-explaining yourself and/or letting yourself be drawn into a deep discussion about it – or even worse, allowing yourself to be persuaded into giving it one more go – is bad news all round and will only be fuelled by your guilt. If you're being bombarded with 'Why?'s be very clear but kind about your reasons behind the break-up.

✃ *Don't be drawn into a tit-for-tat fight*

There's nothing like being hurt to turn the nicest person into a nasty, so if your sweet ex suddenly becomes mean, don't let him blast you because you feel bad. You have a right to break up with someone if you don't feel it's working, so say, 'I understand you're upset so I think it's better if I go home now and we speak later'. Don't answer his texts or calls, and let him cool down for a couple of hours before speaking to him again.

✃ *Make the break-up short but sweet*

Don't have the longest break-up in history, where you turn it into a serial drama and stay on the phone with him for hours and hours every day and then bore all your friends to death with it. Remind yourself you are breaking up in order to get on with your life – so get on with it.

✃ *Don't let your ex rule your life*

So you initiated the break-up, but that doesn't mean your ex can commandeer all your friends and all the sympathy. Be clear to friends about what really happened without slagging off your ex, and don't feel you have to hide until it's all blown over. Remember you may feel like pond scum but you're not, so think onwards and upwards!

Do: Say, 'It's not working as you and I have little in common.'

Don't: Say, 'You bore me to tears and I can't stand being around you.'

Do: Be kind but firm – it's no good giving them false hope.

Don't: Say, 'It's not you, it's me' – they'll hate you for it.

Living
with school

How to survive school (and how to get the best out of it)

You hate going, it bores you to death, the teachers get on your nerves and Friday never comes round fast enough. If those are your more positive thoughts on school here's how to change your mindset.

❀ Get your feelings in perspective. School doesn't have to dominate your life and thoughts even if you do have to be there every day. For a start you only have to go to school for ten months a year, and while that sounds like a lot if you break it down that's five days a week, for only seven hours a day. It's not a lot when you're actually up from around seven a.m. to ten p.m.!

❀ Remember you won't have to be there for ever, so you may as well use all the free resources being offered to you while you can. If you skip classes, refuse to listen and ignore what you're being taught, one day you'll kick yourself for being so stupid or find yourself paying for what was once free.

❀ Use school to get what you want. Whether you want to be famous, insanely rich, a well-known writer, or a nurse or a vet – school is your ticket to that destination.

❀ If you loathe and hate going to school and none of the above helps, another way to survive it is to make sure you have a life outside of school. This doesn't mean just live for your free time, but make sure you do your best at school so you don't have to worry about it when you're home and can have a good time.

❀ You don't have to be a swot or get an A in everything to feel you're reaping benefits. Simply think about what you want from school (besides the bell going for lunch or home time) and make sure you get it. Want to learn how to use a computer properly, play tennis, produce a record, be well read, become an actor or learn how to work a room? Well, it's all there for you through your teachers, friends, lessons, and extra-curricular classes.

❀ Lastly, make sure you get along with people; that's your teachers (see below for more on this) and the people you're in classes with! Being friendly, smiling and generally being someone people want to be friends with can lighten your mood, make even the worst lessons bearable and stop you feeling sick on a Sunday night when another full week of school is looming ahead.

Do: Remember you have to go to school – it's the law!

Don't: Depress yourself by thinking your school years are never going to end.

Do: Something positive if you really hate school – figure out what the problem is and act on it.

Don't: Assume that who you are at school is who you'll be in life!

How to be good at sport

Contrary to what the sporty girls make you think, you don't have to be a lean, mean fighting machine to be good at sports. You also don't have to be into sport to like playing sport (bizarre but true) and lastly, you don't have to be the best at sport to get picked for teams. So here's how to be good at sport.

✤ Give it some effort

You'll never be good at sports if you sit on the sidelines moaning, pretending you have your period every week and sulking about not being picked for teams. To get into sports you have to put in some effort, meaning try a bit. That's try to catch a ball, try to get your head around the rules, and try to look as if you are making an effort when you're standing about on the playing field.

✤ Do something that suits your personality

So you hate team games, loathe athletics and can't bend enough for gymnastics – thankfully there are loads of other sports out there that you could learn to like, so choose one that suits your personality. If

you're not a team player, how about swimming? If you're not competitive, how about aerobics? And if you like being with your mates, how about baseball or football? If all that fills you with dread, think about a sport you would like to try and sign up for classes after school. Just because you don't fit into the sports you have to play at school doesn't mean you're no good at any sport.

❧ Get fit

Most people who hate sport are unfit and don't have the stamina to make it through a lesson, and so feel rubbish and stop trying. Which means to be good at sport you need to get fit. So maintain a healthy diet and make sure your life is active, so your body can cope with the extra exertion sport takes.

❧ Ask for help

Hardly any of us are naturals, which is why, like any other lesson, if you feel you are failing, ask for help. Whether this help is from a teacher, a friend or an extra-curricular class, gaining more knowledge and practising over and over is your ticket to sports success.

🦋 *Have some fun!*

It may not seem like it, but playing sport is not just about winning, impressing teachers or hoping everyone in your school will like you better. It's also about having some fun. Unlike maths and other lessons, there's no homework, no exams (unless you choose to do one) and very little pressure (unless you choose to be on a team), which means it's your chance to simply let your hair down, run about and have some fun for a change.

Don't: Let your friends determine your attitude to sport.

Do: Give lots of different sports a try.

Don't: Give up before you begin.

How to pass your exams

Fifteen ways to sail through with flying colours:

1. Exams are a test of your knowledge, so the more you know the more likely you are to pass, meaning get studying.
2. Have a plan – i.e. know what you're going to study, and when you're going to study. It will ease the panic and help you pass.
3. Ask for help – from friends, family and teachers. Everyone can do their bit whether it's testing you, supporting you or pointing you in the right direction.
4. Look at past exam papers – they'll give you an idea of what to expect in terms of questions and the level of the answer you'll have to give.
5. Finish all your coursework – it contributes to your final score.
6. Keep the exam in perspective, i.e. it's not the end of the world if you don't get the top grade.
7. Accept that you're going to feel stressed – a little anxiety is actually helpful in an exam as it motivates you and gets you in the right frame of mind.

8. Make sure you are studying the right topics —
 it sounds obvious but you'd be amazed at how
 many people study the wrong thing.

9. Eat properly so that you can concentrate — if
 you want the energy to think straight it's better
 to eat before you sit an exam.

10. Arrive to the exam with time to spare —
 otherwise it will take you ten minutes to calm
 down.

11. Read the questions properly before you start to
 answer — otherwise you run the risk of writing
 a great essay that has nothing to do with the
 question.

12. Start with the question you know you can
 answer, to build up your confidence.

13. Not enough time left to write an essay?
 Answer the question in point form, only stating
 the main facts and arguments, so the examiner
 knows that you know your stuff.

14. Keep breathing — it sounds ridiculous but we
 unwittingly hold our breath when we're
 nervous and this is what activates panic.

15. Remind yourself that you have passed exams
 before and you have the ability to pass again.
 So don't have an exam post mortem.

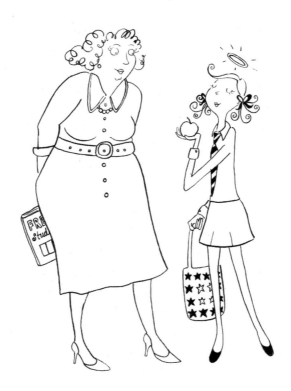

How to make your teachers like you

While no one wants to be teacher's pet, it does pay to get your teachers to like you. Aside from making school life easier, it's worth knowing they are also the people who write your references for college, university and potentially a job, so if you're currently on the teacher hit list here's how to reinvent yourself in a more positive light.

❧ *Don't be annoying*

The smug, know-it-all, moody stereotype of a teenager is no one's idea of a fun pupil; neither is the person who talks in class all the time, nor the one who is always asking annoying and irrelevant questions. So bear in mind if you're disruptive and irritating, that your teachers aren't going to like you, which means you need to choose between toeing the line and making your mates laugh.

❧ *Let them get to know you*

Teachers aren't psychic and don't know that the reason you chat away at the back of the class and never do your homework is because you just don't understand what's going on. Whatever your reason for acting out, talk to them and let them know what the problem is. Aside from helping you do better all round, it also helps them to see you are someone who needs help, rather than someone who is out to simply wreck their lesson plans.

❀ *Take up extra-curricular stuff*

Join a school club, a school team and/or offer to help out with the school play – showing teachers other sides to your personality can also help them to see you as a person and not just a pupil.

❀ *Act friendly*

You may loathe their teaching methods and hate their classes, but they are still people with feelings. It doesn't hurt to smile when you see them in the corridors and say hello when you pass them in the street. What's more, don't gossip about them when they are in earshot; most teachers have bionic ears!

❀ *Be professional*

Your relationship with a teacher is in many ways your first professional relationship (a bit like one you'll have one day with your boss or a work colleague). This means you don't have to have stuff in common, like or even trust them, but you do have to let them do their job. Meaning don't ask personal questions, don't take things personally (unless you're sure they were being personal) and be polite to them.

🦋 *Deal with personality clashes*

Teachers aren't perfect and some simply aren't good at what they do, which means somewhere along the line you may well find you have a personality clash with a teacher. If this is the case and you feel you are being picked on, take action. Tell a teacher you trust what's going on (it's not a secret club whereby they all stick together), talk to your parents and set up a meeting to see what can be done.

> *Do:* Keep an open mind about all teachers until you've experienced them yourself.
>
> *Don't:* Create an 'us and them' mentality.

How to study

If your common refrain is you can't study, ask yourself why. Is it because you don't know how to study (an amazing number of people feel this way) or because you are too distracted to study? Whatever your gripe, here's how to solve it.

1. Understand your brain
The fact is our brains don't remember single facts, but instead interlink everything by association. This means that to get our brains to remember vital facts we have to work with repetition, association and visual imagery, and that's the key to studying effectively.

2. Make a study plan
Bearing the above in mind, you then have to come up with a plan that tells you:
- What hours of the day you're going to study (have the same times each day)
- What topics you are going to study within these hours
- How to break down the topics into sizeable chunks so you get through it all
- What method you're going to use to study – i.e. note-taking, reading aloud, studying with friends
- How you're going to test yourself – e.g. with a friend, with past exam papers

3. Find somewhere quiet to work
Studying in front of the TV, on the bus and/or with your friends around you are all dire study areas because in order to study properly you have to have a quiet and empty space. Meaning no noise that's distracting, such as your favourite TV show, an MP3 player or your mobile, and no clutter that takes your mind off the job – i.e. magazines, friends and clothes

lying all over your bed. Start by finding yourself a clear space in your house or at the library and set up your study area.

4. Know your learning style

This is the way in which you learn best and research has broken them down into two main styles: Auditory Learning and Visual Learning. Auditory learners learn best when they hear information (so you do well in class when teachers tell you what's happening). Audio tapes discussing topics with friends and reading aloud will all help you to digest information more easily. Visual learners study best when information is presented in a written form or with pictures or diagrams. So when you're studying, create pictures in your mind to remember information and at the same time take notes so that you can literally see what it is you're studying.

5. Take notes by hand

Rereading your notes is a passive way of learning and one that leads to boredom and distraction, so when you're studying take notes. Studies show that writing down key points, as opposed to reading them or typing on a computer, triggers learning in the brain.

6. Stop stalling

Just do it. Insisting on tidying your room/helping your mum, getting a snack and/or deleting emails

before you begin are just delaying techniques that we all use. Put your blinkers on (so you can't see anything around you) put your head down and start studying!

Do: Take regular breaks – ten minutes every hour.

Don't: Cram, unless it works for you.

Living with family

How to end sibling rivalry

No matter how old you are, it's never too late to improve a relationship with a sibling, once you realize most fighting is about jealousy, competition and personal space. If you're at loggerheads here's how to end your rivalry once and for all.

1. Break your childhood habits
Our knack for behaving like five-year-olds is often automatic, so you have to make a conscious effort to break free of your old patterns. The next time you feel that a fight is brewing, step back, take a breath and take a break from each other until the moment has passed.

2. Don't hold a grudge
So when your sister was eight she broke all your toys and pushed you down the stairs – as justified as you think you are to still feel angry five years later, it's time to let go and move on.

3. Say sorry more often
Apologizing to each other may not be something either of you are used to, but if you start she/he will follow. There's quite a lot of power in an 'I'm sorry' because it tells the other person that their feelings have been noted and responded to.

4. Avoid being sarcastic
All it does is send a minor disagreement from zero to ten on the let's-have-a-fight scale.

5. Think before you act or speak
We're all guilty of treating our siblings worse than we treat anyone else. Next time something hurtful comes to mind, or you find yourself about to do something that you know will upset your sibling, stop, think and change tactics.

6. Accept they are different to you
Remember their choices aren't rubbish just because they are not yours.

7. Take a sibling break
Meaning don't spend so much time together – when you're home, try and keep some distance and if they won't leave you alone, don't face off against them, ask a parent to intervene.

8. Don't let your parents push you together
They want you to be best friends, you know it's never going to happen – so the next time they insist you do X, Y and Z together, tell them that you don't get on and they're making a bad situation worse. They won't get mad as long as you emphasize you'll try harder to get on, if they try not to push you together.

9. Have an It's My Day rule
If you can't agree on who sits where in the car, who watches what on TV or who's been on the computer the longest, start an It's My Day rule where each day you swap who's in charge.

10. Talk about what's bothering you
Instead of fighting about the fact that she's wearing your jeans and reading your magazine, tell her what's really bothering you – the fact she takes you for granted and doesn't ask before borrowing. Communicating is the key to stop the bickering.

Do: Bear in mind that you won't be living together for ever and will one day miss him/her.

Don't: Get your friends involved in your fights.

Do: Treat her/him the way you want to be treated.

Don't: Always assume she/he's the one in the wrong.

How to argue and win

They may have the upper hand being older, potentially wiser and more in control than you are, but it is still possible to win an argument with your parents. Here's how:

Know your opponent

As in know what your parents are likely to say, what triggers their anger and frustration, and how you're going to respond to what they say before they say it. It can help to role-play your argument in advance with a friend pretending to be your mum, or have

an imaginary conversation in your head that covers all bases – the good, the bad and the ugly!

Keep your cool at all times

Get riled up, become aggressive and burst into tears and you've lost before you've even started. The way to maintain your cool is to breathe and take a breath in when you feel your throat getting tight with anxiety. If you find you're in a panic, stop, take a deep breath and then speak.

Know your outcome

If you want to argue effectively and win, you have to know what you're fighting for – don't get drawn into an argument just for the sake of it. Have a clear objective and know what you want. Also figure out how you're going to achieve your goal with the least pain possible.

Make sure you're right

Are you really fighting for the right thing, because if your desired outcome is wrong you're never going to win your argument in a hundred years. If you're unsure, run it by a few people that you trust before you talk to your parents and gauge their reaction. If a friend says you're wrong – believe her!

🦋 *Argue effectively*

Know your point, keep repeating it and have a structured argument in place. For instance, suppose you're fighting about having a party, tell them why you want one, why you feel you might deserve one, how you're going to help organize it and pay for it, and why they shouldn't be worried about a mess or a potential guest problem.

🦋 *Have a Plan B*

So that if they completely knock back your original plan, you have a compromise up your sleeve that will be as good as a win. For example, if they say no to a party at your home, ask if you can hire somewhere cheap and have that as a birthday present. If it's a later curfew you're after, promise if they agree to it this one time, you'll stay in all week to make up for it.

🦋 *Don't push your luck*

When you've won an argument with your parents it's easy to feel so pumped up with confidence that you go for something more. A word of advice – don't do it. Pushing your luck can make your parents reconsider everything they have just agreed to and start the argument all over again.

> *Do:* Compromise – you can still get close to what you wanted.
>
> *Don't:* Get angry if you lose – put it down to experience.

How to beat your curfew

Aside from climbing out of the window when your parents are asleep, there are easier (and safer) ways to beat your curfew. Firstly think about why you have one – are your parents just being mean (doubtful), overly protective (possibly) or trying to ensure you get enough sleep (most likely). Knowing the real reason why they have given you a curfew can deflate the feeling that you're being babied or treated unfairly, and so stop you breaking it or give you an idea of how to tackle the problem.

When you ask them, try to do it in a non-aggressive and non-confrontational way so they don't feel obliged to say 'because I said so'. Then negotiate. This means talking to them about extending the time you're allowed out against the time they want you in. The way to do this is to simply ask if on weekends and holidays you can have an extra thirty

minutes. It may not be what you want but the aim is to start small and build up to a time that suits you better. Thirty minutes is a time most parents will rationalize they can deal with and with a bit of pleading you should get it.

When you have your extra thirty minutes you have to – and this is an absolute rule – stick to it. Better still, sometimes come in well before your curfew. This shows your parents that (1) you can be trusted and (2) you are able to know when you've had enough and it's time to come home. Flouting the rules, getting in even five minutes after the extended period, or ignoring your deadline completely screams: 'I need a firmer hand.'

When you've stuck to the time for a number of weeks, start to make them feel more at ease by telling them where you're going, and letting them meet who you're going with. Most parents come down hard when you play the 'Why should I tell you where I am going game?', because it makes them believe you're up to no good, so reassure them before they ask and you could find them loosening up on their time limit.

The next step is to call them when you're out. This may seem like the weirdest thing to do but again helps them to feel reassured that you're OK and reminds them that they can contact you whenever

they want. (If it's potentially embarrassing in front of friends, excuse yourself and do it in the loo or, even better, text them, as this is subtler.)

Your last step is to wait a few weeks and put all of the above together, with the aim to extend your curfew even further by pointing out (1) you can be trusted – after all, you've never broken your curfew (2) they know who you're with and where you'll be – having met all your friends and (3) that you may not really stay out till the set time and if they need you they can call you – having already shown them you sometimes come in early and you always have your mobile on!

Do: Stick to the rules even when you have an extended curfew time.

Don't: Take liberties – your parents will come down on you like a tonne of bricks.

How to be friends with your parents

Friends with your parents – are you kidding? They annoy you, boss you about, never listen and moan constantly at you; why would you even consider being friends with them? Well, because being mates with your parents pays off in numerous ways. Firstly, it helps you to understand each other better, secondly, it teaches you to trust each other, and lastly, it just makes life easier when you genuinely like, as well as love, each other. So here's how to do it:

Realize they are more than Mum and Dad

You may think their role in life is to be your mum or dad, but aside from this they are someone's child, best friend, boss, employee, relative, neighbour – the list is endless, which means, like you, they have a multitude of roles to play and people to please. Realizing this can help you to understand why they might be snappy or distracted when you start asking for something and also why they complain about being tired all the time.

🦋 *Ask about their lives*

Think about how you make new friends, you start by finding out information about them. Can you name your mum's top five likes and dislikes? What films your dad loves? Whether they like their jobs? Or who the first boy your mum ever kissed was? (OK you may not want to know or think about that!) If not, the next time you're sitting down with them, talk to them and ask about their lives for a change. It will help you to see if you like them and what you have in common besides being related by blood.

🦋 *Talk to them properly*

If your constant whinge is that your parents don't understand you/know you/listen to you, consider if you're talking to them properly. Getting angry, snappy or sarcastic with them when they can't remember that you hate maths, or want to spend a year travelling around the world, or have just been dumped by your boyfriend probably means that you aren't relaying information to them properly. Sometimes you need to spell things out clearly and consistently as if you were chatting to a friend.

🦋 *Keep in touch*

In the same way you keep in contact with your friends, it pays to do the same with your parents. Texting them a 'hello' during the day or emailing them to see if they are having a good day, alerts them to the fact you're as concerned about them as they are about you, which in turn makes your relationship more equal and balanced, leading to more trust all round.

🦋 *Let them in*

Allowing your parents into your life not only makes them feel happy but also creates trust. Introduce them to your friends, tell them about the problems you're having, ask them for their help – you don't have to tell them everything, but letting them be more than your mum and dad helps them move away from the role of always feeling they have to tell you what to do.

🦋 *Help them with their problems*

If they're stressed, miserable or fighting with their friends, offer them support, and help or just do something nice for them. You'd do it for a friend so do it for the people who do the most for you.

> **Do:** Give them time to come round to the idea of being friends as well as family.
>
> **Don't:** Rush it – it will freak you both out.

How to avoid being guilt-tripped

The trouble with parents is that they know you and know you well, which means they have a knack of making you feel guilty when you don't want to do what they ask. Whether it's a sad, hurt look thrown in your direction, an 'I'll just do it myself like I do everything' comment or a 'Don't you want to spend time with us?' remark, it's all designed to put you on one big guilt trip. If you're tired of being manipulated, here's how to avoid the trip!

1. Realize that a guilt trip is what happens when you dare to say no to someone you care about
You turn someone down, and then in an attempt to force you to change your mind, they try a number

of tactics such as emotional blackmail, anger and pain (see above). Their success in making you feel guilty is directly related to how much they know you need their approval. So don't be a people pleaser all the time.

2. Second-guess their reaction

This means saying, 'Sorry, no I can't do that because . . . and I know that upsets you but . . . ' before they have a chance to say anything, thereby cutting off their chance to go on about the level of their pain and disappointment and limiting their ability to put you on a guilt trip.

3. Remember they'll get over it

Disappointment is fleeting when it comes to trivial things, and only gets larger if the stakes are higher. Which means if you're going to say no, make sure it's not to something that your parents will never get over like a family wedding, funeral or birthday. Risk that guilt trip and you'll be riding it for ever.

4. Tell yourself not to feel bad

You can't always do what other people want you to do and sometimes have to do what you want. It's not selfish and it's not bad, so you don't have to feel bad about it. Remember they asked you if you wanted to do something, and with questions you don't always get the answer you want.

5. Stop thinking about it
As hard as it is, guilt trips are perpetuated by constantly going over what happened when you said no, which means rather than enjoy the outcome of having stood your ground you end up feeling miserable and unhappy. So don't think about it and move on – it sounds harsh but it works.

6. Make sure you don't say no to everything
A guilt trip is magnified if your parents can rattle off a list of ten things you said no/let them down over. So if you don't want to feel guilty, don't give them too much ammunition. Instead when you say no, get in first with your guilt trip and remind them of all the times you said yes, did what they wanted and changed your plans. It's sneaky but it works!

Do: Let them tell you how sad it makes them feel that you won't do something.

Don't: Dismiss their feelings, just choose to put yours first for a change.

Living
green

How to recycle

The average person in the UK throws out their body weight in rubbish every seven weeks, and 80 per cent of that could be recycled. Aside from paper and glass, plastics, food, packaging, clothes, shoes, garden waste, tins and even metals can be recycled and used again. Plus recycling doesn't just mean ditching the stuff you don't want in a bin for someone else to take away. It also includes recycling the things you don't want, like taking clothes, books, CDs and household items to charity shops and/or offering them to your friends. It's also thinking about reducing what you buy overall so you don't have to recycle that much in the first place. So repeat to yourself the mantra: reuse, recycle, reduce.

- Reuse – for instance, old T-shirts make good household dusters.

- Recycle – can you give it away or place it in the recycling bin?

- Reduce – cut back on your needs and so throw away less. Thankfully this doesn't mean having to do without or becoming a tree hugger, but simply rating your purchases before you buy them. For instance, do you need the latest DVD or CD when you can either borrow it from your friend or download it online? Do you really need another bag when you have ten at home, or more trainers when you own five pairs already?

It may seem like a boring way to live but bear in mind that even the smallest changes can make a huge difference to the planet so:

- *Borrow or swap with friends before you buy something new* – not just clothes, but DVDs, magazines and even shoes.

- *Always reuse plastic bags* – most people throw away four bags a week (which is huge when you add it up). Buy a cloth bag and use it everywhere you go.

- *Think about packaging waste* – do you need a plastic bag from every shop you go to, or a wrapper around your apple, or a box with your new shoes?

- *Take your recycling to a recycling bin* and separate it yourself rather than dumping it in one box and letting someone else separate it. This takes more energy and is a less green option.

- *Persuade your parents to read their newspapers online* – it's free and has no waste paper.

- *Buy recycled toilet paper* (it's made from recycled paper, not recycled toilet paper!)

- *Recycle your old MP3 players and mobile phones properly* – you can't just chuck them in the bin.

🌸 **Don't always think you need the latest gadget –** if you have a mobile that works properly, do you really need a new one just because it's being offered to you?

How to be a green shopper

To be an eco-friendly shopper, you could try shopping in green and eco stores and refusing to be part of any mainstream chain. You could even grow all your own vegetables and start making all your own clothes. But let's get serious for a moment – a girl's got to shop! So if you have to do it, at least do it with some green style.

🌸 **Tip one: Bring your own shopping bag**
Plastic bags are an eco nasty, and each year an estimated five hundred billion to one trillion plastic bags are consumed worldwide. That comes out to over one million per minute. They're bad because they don't biodegrade, instead they do what's known as photo-degrade – breaking down into smaller toxic bits contaminating soil and waterways and entering the food chain when animals accidentally ingest them. Currently, thousands of sea mammals and

creatures die every year from eating discarded plastic bags mistaken for food. Which means it pays not to use them. Instead buy one of the many charity reusable and trendy cloth bags currently on the market, and shop with style while doing something good for the environment.

✿ *Tip two: Use your consumer power*

You may be too young to vote or get a part-time job, but if you have money to spend you have what's known as consumer power. This means you can choose where you shop and so can vote with your feet. So if you know of a well-known shop that uses child labour in the developing world to make their clothes or shoes, choose not to shop there. Or if you know of a brand that has a bad eco record in manufacturing their goods, don't buy it. If enough people do it, it will make a difference to the company and they should change their ways.

✿ *Tip three: Buy Fairtrade and ethical goods*

Ethical means that everyone involved in making the product you are buying gets a fair deal in terms of workers' rights. In most cases this means the item is made in factories that are inspected so that the people working there get a fair wage. The Fairtrade Mark on the other hand

is an independent consumer label, which appears on products as a guarantee that the people making the clothes/shoes/products in the developing world are getting a good deal.

Tip four: Spend wisely

This is the biggest eco-friendly thing you can do when shopping because by considering if you need something before you buy it you are helping to reduce the amount of wastage in the world. So always rate your purchases out of ten. If you're scoring a seven or below, you don't really want it. Score an eight then go home and think about it, and only when you have a nine or ten should you buy it!

Do: Shop with friends so you can avoid buying something if you know they can lend it to you first.

Don't: Buy anything without thinking about what you have already.

How to be fashionably green

Being eco-friendly about your clothes doesn't have to mean hemp knickers and politically correct T-shirts (unless of course you want to don that stuff)! It's about considering what you're buying

and why, so aside from incorporating the green shopper tips above, try:

🦋 *Going vintage*

It's sexy, it's cool and all the celebrities do it and it's also cheaper and eco-friendly. Yes, vintage/ secondhand/used – call it what you may – is big business, with most of the high street chains doing a small version of their own. If your local secondhand shops have nothing you desire, get your friends together for a vintage sale. Get everyone to bring ten items and swap and sell your clothes, accessories, bags and shoes amongst you. You'll be amazed at what bargains you find.

🦋 *Wearing everything you buy*

It sounds stupid, but before you go shopping look through your wardrobe and make sure you regularly wear everything you own. Between 2001 and 2005 the number of clothes bought per person increased by over a third. This is bad news on the green front because most of us have a disposable attitude to clothing, i.e. we buy something cheap, wear it once or twice and then throw it away. Clothing that is recycled currently accounts for 13 per cent of clothes chucked away and could well account for over 80 per cent, so if you're not going to wear something consider the fact that someone else will, and recycle it.

🦋 *Taking good care of your clothes*

If your clothes are currently littered across your bedroom floor and under your bed, you need to pay more attention to them, because with a little bit of care, clothes and shoes can last a long time. Which means mend rips, repair the heels on your shoes and don't just buy something new because you have nothing clean in your cupboards. Clothes may be getting cheaper, but that's only because more people are getting ripped off and more chemicals are being used to make them.

🦋 *Considering eco-friendly clothes*

These are clothes made from eco-friendly fabrics such as organic cotton and organic denim, bamboo, hemp and soy silk. These are all good news on the eco front because, unlike normal cotton, they are replenished easily and in a relatively short amount of time, so the size of their carbon footprint is small.

🦋 *Washing your clothes on thirty degrees*

Rather than whack your washing machine up to boiling point when you're helping out your mum, consider the fact clothes get just as clean and last longer if you wash them on thirty degrees. Studies have shown that this small change reduces electricity consumption by around 40 per cent on average.

What's more, wash your clothes less often to save water, unless of course they're filthy, in which case wash them and hang them out to dry, as a tumble dryer is particularly bad for the environment.

Do: Tell your friends about how to be fashionably green.

Don't: Think small changes can't make a difference, they can.

How to be green at school

While many things about school are out of your control, such as homework, miserable teachers and hours of maths a week, you can make a difference on the eco front and here's how.

Think about how you get to school

Do you get a lift off your mum or jump on the bus, or do you walk? How you decide to get to school and back has a direct impact on the environment, because if you're making around four hundred car

journeys in one school year you're playing a part in climate change. So while it may be easier to have thirty minutes more in bed and get a lift bear in mind that getting up earlier and walking or taking public transport is the more eco-friendly option.

✤ *Buy reusable stationery*

There are lots of ways that you can also reduce waste at school by thinking ahead and being creative. For starters, don't use disposable stationery, look for durable, long-lasting pens and school bags and reuse them, for example, refillable pens, and notebooks made from recycled paper. Also buy items that can be used more than once and will reduce waste and save you money.

✤ *Recycle all paper*

Next think about all of the paper you've thrown away from homework or in class that had writing only on one side – or printouts you've binned without thinking. Try to use this paper as scrap paper at home, or recycle it. By using less of it at school you can reduce up to 40 per cent of the trash that is thrown away by your school.

✿ *Pack an eco-friendly lunch*

Think about the packaging your lunch comes in. If you're bringing your own lunch, always try to use reusable containers so that all the packaging does not end up in the bin. For instance, instead of buying mini packets of crisps and treats, buy a large bag and separate portions into reusable zip-lock bags every day. Also avoid buying fruit that's been wrapped and buying a bottle of water a day – bring your own from home. If you're buying takeaway, choose places that either have reusable plates or eco-friendly packaging that's recycled (many of the well-known fast food places do this). Finally, if you're eating at school ask your school cafeteria to have a food waste bin, for all the food that doesn't get eaten. Many councils provide services that collect food waste to turn into compost.

✿ *Start a campaign*

It also pays to be proactive and think of all the ways your school wastes energy and then start a campaign to do things like switch off lights in classrooms at break and lunch and when the final bell goes. Ask for a recycling bin in every classroom and a box to put paper that has only been used on one side. Finally, can your school go paperless? Ask your teachers if you can hand in assignments on a disk or

via email and if notes and letters to parents can be sent by email. It's a giant step, but some schools are already doing this with great success.

Do: Remember studies show that 80 per cent of school journeys are under five miles and 33 per cent are under one mile – meaning both are easy to do by public transport and/or on foot.

How to be green at home

Being green at home is easier than being green at school, but it does involve you actually doing something, so if your mum currently does everything from shopping to washing to cleaning to cooking, sorry – you're going to have to get involved. Here are twenty easy ways to be green at home:

1. Don't fill the kettle when you want a cup of tea.
Just boil one cupful at a time. If fifteen families did this for a year, a tonne of CO_2 emissions would be saved.

2. *Wear a jumper and turn your heating down.* Turn it down by one degree and this could save your mum enough money to buy a new pair of shoes.

3. *Don't leave your computer on standby.* Leaving the monitor on at night wastes enough power to cook six microwave meals!

4. *While you're at it, take your DVD and TV off standby*. In the UK £163 million of electricity is used by TV and DVDs being left on standby.

5. *Always turn lights off as you leave a room.*

6. *Shower rather than bathe.* A standard shower uses just 35 litres of water, compared to a bath, which uses 80 litres. But don't power shower as this uses about 80 litres of water. If you have one installed, buy a water-restricting showerhead.

7. *Switch off as you soap up.* If you're spending time lathering up your body and hair, turn off the shower to save water just being wasted down the drain.

8. *Flush less.* Obviously flush what needs to be flushed, but you can afford to do it less often as the average house flushes 50 litres of water down the toilet every day.

9. Turn taps off as you brush your teeth and you'll save up to 5 litres a minute. If the entire adult population of England and Wales did this it could save a total of 180 million litres a day – enough to supply nearly 500,000 houses.

10. Change your light bulbs. If every household used energy-efficient light bulbs in just one room, the nation would save more than 800 kilowatts of energy and keep £1 trillion of greenhouse gases out of the air. The bulbs are more expensive but they last twelve times longer than normal bulbs.

11. Use a microwave to cook. It's faster and more efficient than using an oven and will reduce your energy usage by about 75 per cent.

12. Hang your clothes up to dry. You will save 320 kilograms of CO_2 by air-drying clothes as opposed to tumble drying if you do it for six months of the year.

13. Upgrade old computers rather than throw them out for something new.

14. Recycle your old trainers – either give them to a charity shop or check out one of the many sports brands that will recycle them for you.

15. Don't buy kitchen roll – get used to using a cloth that can be washed and reused.

16. Don't rush to get a new mobile phone, but if you do, don't bin it (phones have toxic components) – instead give them to charity for reuse.

17. Put lids on pots when you're boiling your food – it cooks quicker and uses less energy.

18. Close windows when you have the heat on – it saves energy and stops your parents having to pay large bills.

19. Collect rainwater – you can use it to water plants.

20. Recycle all your electrical goods such as mobiles, old computers and DVD players – never just dump them in the bin as they have components that can be toxic in a landfill.

OK, so you've read the book, toyed with the tips and even thought about experimenting with some of the advice. Apart from giving yourself a large pat on the back there's one last thing to remember: whatever you're struggling with, be it bras, boys, bad hair days or more, you have the power to turn things around. So don't wait to be pushed – hold your head up high, take a deep breath and go forth and conquer your life with style . . .